WHITBY ABBEY & ABBEY HEADLAND

THROUGH TIME

Alan Whitworth

AMBERLEY PUBLISHING

*I should like to dedicate this book to the staff of English Heritage,
who do a marvellous job of preserving the past for the future.*

*Also, in particular, to Sarah Eastell, a lady of wit, intelligence and a wicked
sense of humour, who I came into contact with in the production of this work.*

First published 2012

Amberley Publishing
The Hill, Stroud
Gloucestershire, GL5 4EP

www.amberley-books.com

Copyright © Alan Whitworth, 2012

The right of Alan Whitworth to be identified as the
Author of this work has been asserted in accordance
with the Copyrights, Designs and Patents Act 1988.

ISBN 978 1 4456 0672 9

British Library Cataloguing in Publication Data.
A catalogue record for this book is available from
the British Library.

Typeset in 9.5pt on 12pt Celeste.
Typesetting by Amberley Publishing.
Printed in the UK.

Introduction

The foundation of Whitby Abbey was, in part, due to the fulfilment of a vow made by the Christian King Oswy, of Northumbria, before the Battle of Winwaed in AD 655, against the heathen King Penda, of Mercia. Oswy undertook, in the event of victory, to establish twelve monasteries on his estates: six in Deira and six in Bernicia. Victory was achieved, and the Abbey at Whitby was set up in AD 657 under the rule of St Hilda (614–80); a double monastery of men and women that formed a characteristic feature of the early Anglo-Saxon Church.

Whitby Abbey figures largely in Bede's *History of the Anglo-Saxon People*, and it rapidly achieved a high reputation both for piety and for ecclesiastical training. In time it became the burial place for members of the royal house, not least because Oswy also gave his daughter Aelfleda to the monastic life as part of his vow. She became the second Abbess at Whitby after Hilda, coming here with St Hilda in AD 657.

Two events stand out in the Abbey's early history: the Synod of Whitby and the career of Caedmon. The Synod took place in AD 664, having been convened by King Oswy to settle a number of clerical and liturgical matters that had arisen between the Roman and Celtic elements of the English Church, and in particular how the correct date of Easter should be resolved.

Caedmon (*d*. 680), who became the most celebrated of the vernacular poets of Northumbria, was a farm worker on the lands of the Abbey during the days of Hilda, and known to be illiterate. It was following a vision or dream that he began to compose verse, his most famous work being the 'Hymn of Creation', which is the first written English poetry.

The Anglo-Saxon Abbey was destroyed by the Danes in AD 867, and the site of the ancient monastery laid waste for more than two hundred years. It was re-founded as a priory around the year 1078 by Reinfrid, a monk from the Benedictine Abbey of Evesham in Gloucestershire. For some time the new Norman Abbey flourished, but by the fourteenth century it had gone into decline. The Suppression of the Monasteries by King Henry VIII from 1539 closed the monastery as a religious house, but the Abbey church, although robbed of its lead roofs, was suffered to remain intact for a number of years afterwards while many others were pulled down, although eventually the stone was reused in the erection of Abbey House.

From 1540 the property belonged originally to the Cholmley family, and subsequently to the Fanes through marriage. The gradual deterioration of the building over time can be studied in the long series of engravings of which it has been the subject, and much of the stone was

taken away to construct Abbey House and other properties. The great central tower fell on 24 June 1830, and damage was caused by German bombardment during the First World War. Subsequently, in 1920, the Abbey was given into the guardianship of HM Office of Works, later the Ministry of Public Building and Works, now called English Heritage.

The construction of the present church dates from the 1220s. Archaeological excavations marked out on the ground show that the earlier church was smaller, and the chancel had a rounded end, or apse. Excavations in 1924–25 to the north of the Abbey revealed remains of the Anglo-Saxon monastery, which unfortunately were not left exposed. The later church is of the Early English style of architecture. After the east end of the second church was completed, the north and south transepts, the central tower and three bays of the nave were not begun until some twenty years later. By that period the cost of the work had put the Abbey into enormous debt. The remainder of the nave was not completed until the fourteenth century and the great west window was inserted in the Perpendicular style a century afterwards.

Today, the Abbey ruins are, without doubt, one of the most moving sites in England; situated on a bare, wind-swept cliff, fully exposed to the elements. Iconic and instantly recognised, they are very different from the great sheltered Cistercian valley ruins of Rievaulx and Fountains.

The seal of Whitby Abbey was discovered about the beginning of the nineteenth century at York, affixed to a lease granted by Henry de Vall the last abbot and dated 10 January 1538–39. One side shows an elegant portrait of the Lady Hilda, with her left hand on her breast, and her right holding a crosier; the legend reads – 'The image of the Virgin Hylda'.

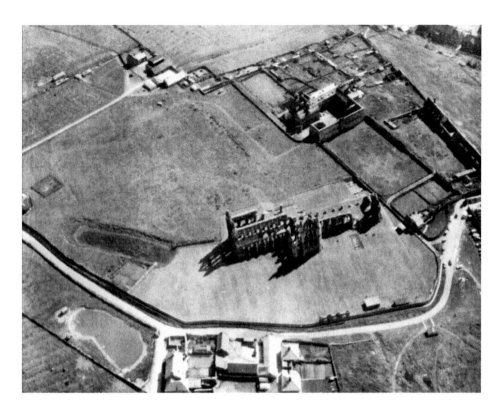

Whitby Abbey from Above

An aerial photograph taken in around 1960 provides a wonderful view of the main components of the Abbey Plain. Abbey House can be clearly seen, and in particular the roofless banqueting hall. At this date Abbey House was a hotel and the YHA hostel was situated in the long buildings to the top right. At the time there were two fishponds in which the monks bred fish to eat, one on each side of the road, but today the lower one on the farm appears to have dried up (compared with page 6).

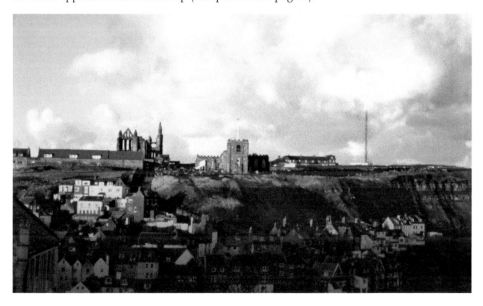

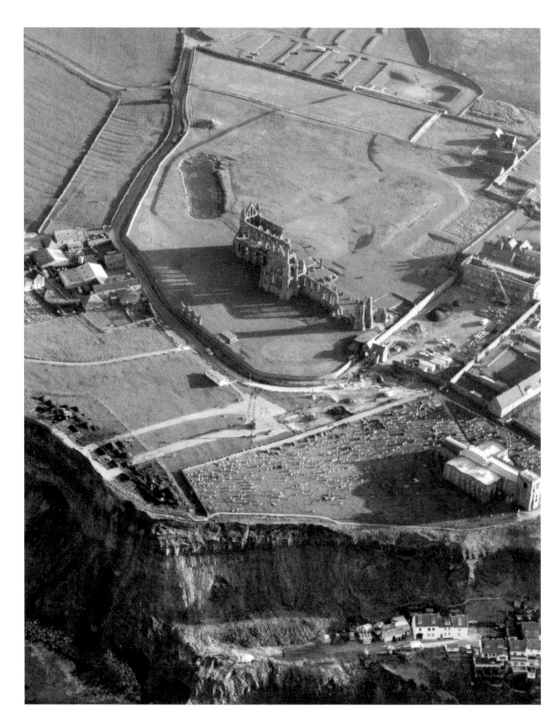

The Abbey Headland from Above

This photograph shows work underway on creating the new visitors' centre – which opened in 2001 – and the archaeological excavations being carried out on the cliff edge before this part of the headland fell into the sea. An amazing image, it is possible to really appreciate the amount of coastal erosion. The churchyard of St Mary's is only half the size it was, and below, a huge length of Henrietta Street has slipped away over time, leaving only a fraction of its length today.

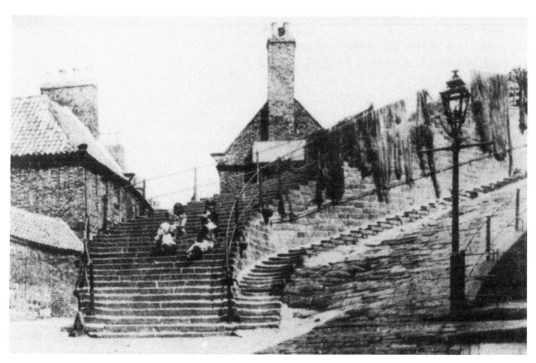

The 199 Steps, Whitby

The famous 199 Steps lead up to the church of St Mary's and the Abbey headland. The original steps were made from wood and numbered only 190 before they were replaced by stone. During renovation work over a century ago the number was increased to 199. Until 1833 there were no railings. Flat resting places were constructed for the 'easement' of coffin bearers, as most of the older generations of Whitby preferred to be 'carried' to their last resting-place rather than be 'driven'. Beside the steps is the very steep, cobbled 'donkey' road.

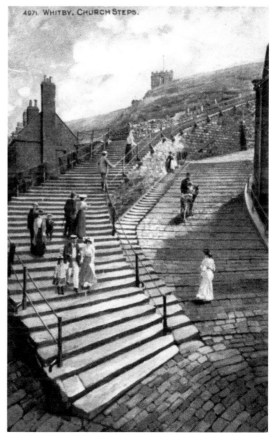

4971. WHITBY. CHURCH STEPS.

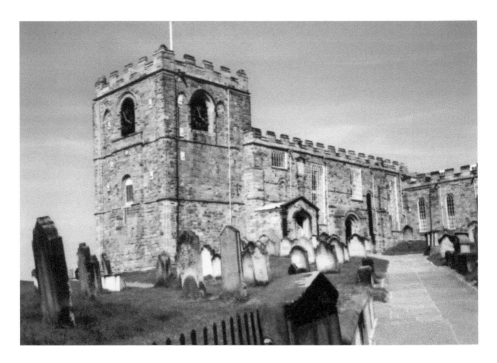

The Parish Church of St Mary's, Whitby

The church of St Mary's has Saxon origins, and Norman work survives, but it is most remembered for its unique interior of galleries and box pews. Bram Stoker, the author of the book *Dracula*, set a large part of the story in Whitby, and stayed here on a number of occasions. Most of the names of the characters in his novel were taken from the tombstones, many of which today are incredibly weathered and blackened by time and the days when a pall of smoke covered the town from industry and home fires.

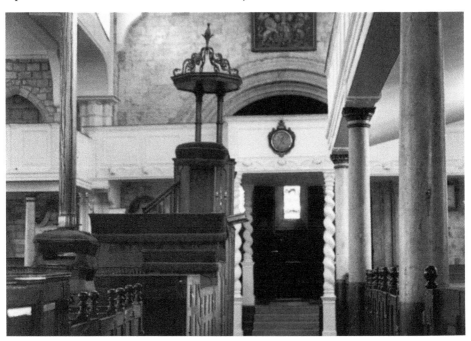

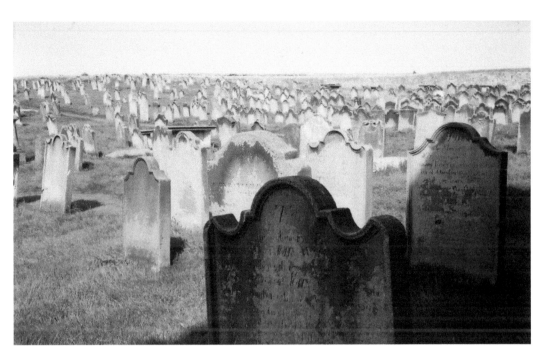

The Burial Ground of St Mary's Church

Alfred, Lord Tennyson (1809–92), the poet laureate, visited Whitby in 1852 and wrote, 'I am set down here for a week at least in lodgings. It is rather a fine place, a river running into the sea between precipices, on one side new buildings and a very handsome Royal Hotel belonging to Hudson the railway king, on the other at the very top a gaunt old Abbey, and older parish church hanging over the town amid hundreds of white gravestones that looked to my eye something like clothes laid out to dry...'

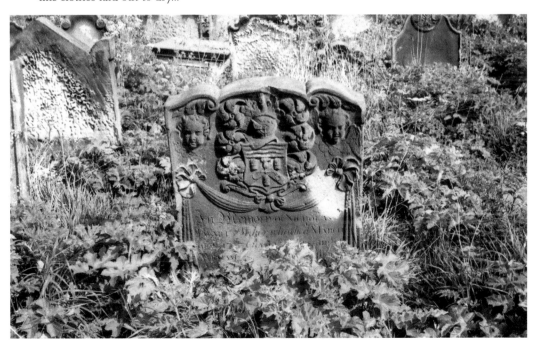

9

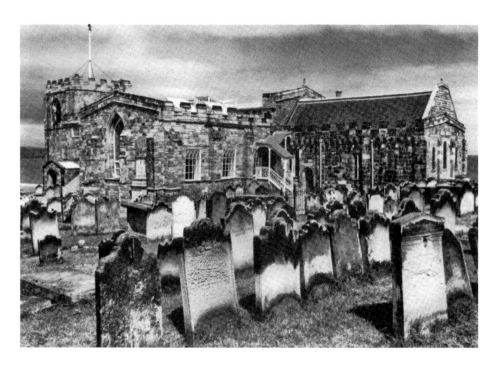

St Mary's Parish Church

In 1864, Shirley Brooks, who had spent a holiday here, contributed the following to *Punch* magazine: 'There is a church (horribly churchwardened with galleries) on the highest of hills, and you can ascend it by one of those awful roads which frighten you in nightmares. Or you may climb up exactly as many stairs as there are feet in the Monument, London. Or you may go by a wide, but easy circumbendibus. You will be amply rewarded, not only inside the church (which is served excellently), but by the sight of some glorious old ruins...'

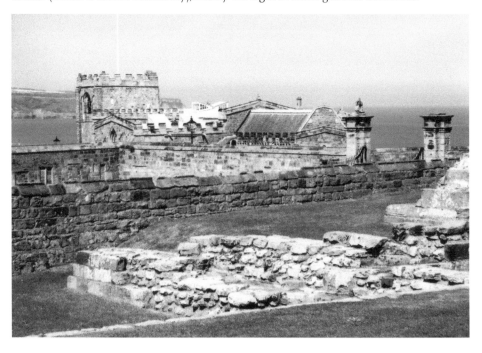

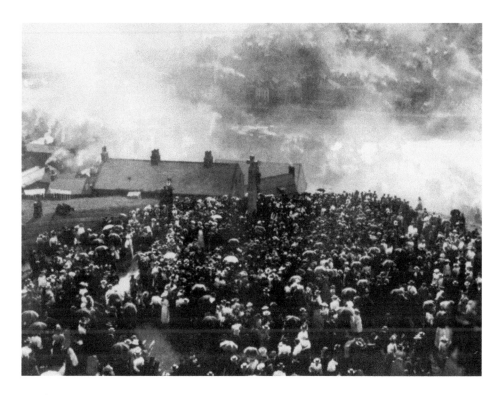

Caedmon Cross, Whitby

One of the most prominent monuments of the Abbey headland is Caedmon's Cross, erected in memorial of the famous illiterate cowman Caedmon (*d.* 680) of St Hilda's monastery. He had a dream and in the morning was able to sing and create beautiful poetry, he is known as the father of English literature. Caedmon's Cross was unveiled on 21 September 1898 by the then poet laureate in front of a huge assembly. The cross is carved in the manner of an Anglo-Saxon cross with intricate sculptured panels.

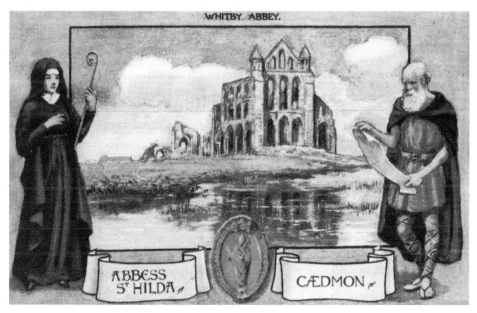

11

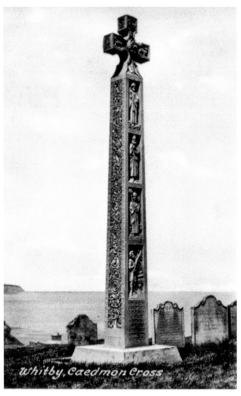

Whitby, Caedmon Cross

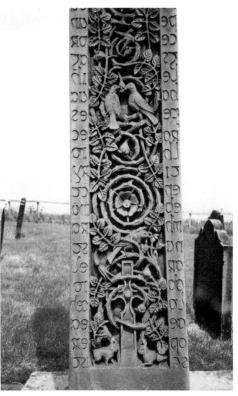

Caedmon's Cross

Caedmon's Cross was chiefly obtained through the exertions of Canon Rawnsley, of Keswick, who opened a public subscription fund in 1878 to raise the necessary finance. It was unveiled by the poet laureate Alfred Austen. The memorial is based on the design of an Anglo-Saxon cross, and is of hard sandstone. It stands on a stone base and is 20 feet high. Designed by C. C. Hodges, and carved by Robert Beall, the front shows four carved panels representing Jesus in the act of benediction, the psalmist playing the harp, St Hilda bearing the Abbey staff, and Caedmon in the cow shed composing verse. Beneath is an inscription that speaks of Caedmon having fallen asleep 'hard by' in AD 680. On the reverse side is a double vine design, in the loops of which are the figures of four of the great men who were resident at Whitby Abbey during the lives of Hilda and Caedmon: Bosa, Aetla, Oftson, and John of Beverley. Beneath this and on the base the opening lines of Caedmon's 'Hymn to Creation' (written *c.* 670) are engraved, taken from the *Moore Baeda*, preserved at Cambridge.

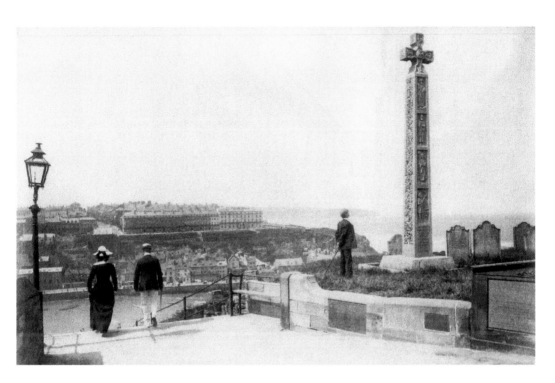

Caedmon's Cross Looking Toward Whitby

Two views looking across the town and harbour; little has changed, just the fashions of the visitors, but the upper photograph must have been taken before the tower of St Hilda's church in the West Cliff Estate – clearly seen in the bottom photograph to the left of the lamp – was completely in 1938 to the design of G. E. Charlewood, as it appears to be missing from the older image. The tower of St Hilda's is said to be an exact replica of the tower of Whitby Abbey before it fell.

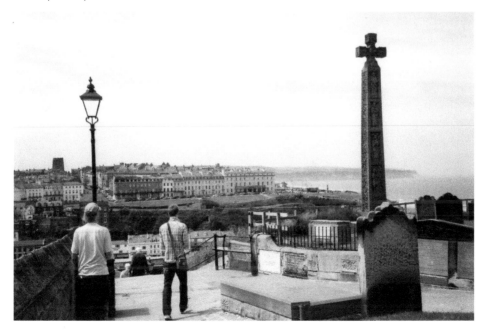

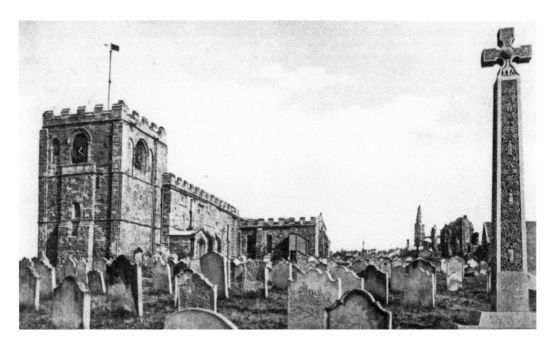

St Mary's Church and Caedmon Cross

Two unusual views of St Mary's, the parish church of Whitby. Above, a photograph taken in 1914 shows the church and the Caedmon Cross. The tower of the church has in previous centuries been reduced in height, while below this is the north elevation of the parish church showing the lancet windows that were retained on this aspect, except for two 'domestic' windows fitted into the fabric beside the tower. Elsewhere, apart from the Norman chancel, all the others were replaced with 'domestic' windows in the eighteenth century.

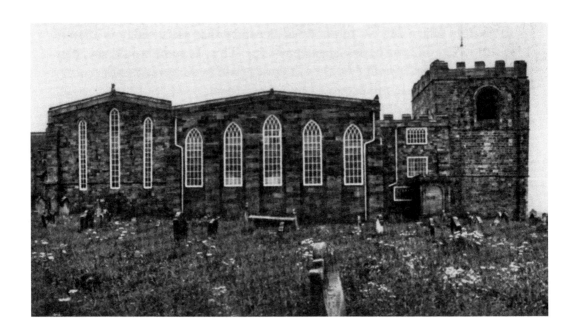

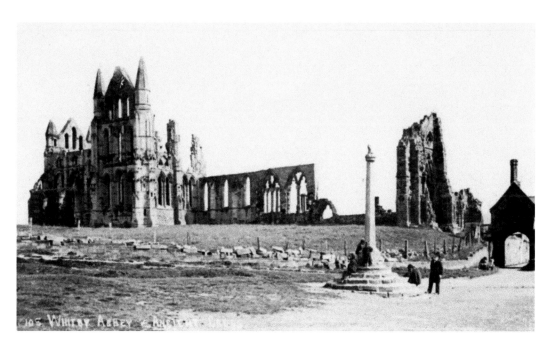

The Abbey Wall

An interesting view showing the foreground wall, which was partly demolished by Revd Francis Haydn Williams, a 'turbulent' priest who came to the Unitarian chapel, Whitby, in 1888. One of his many campaigns concerned the wall surrounding the Abbey, he alleged, which interfered with his 'rights of way'. He and a few other like-minded individuals pulled it down. For this and other offences of failing to keep the peace he served a short time in prison. The displaced stone walling, behind the fence, was probably the remains left by the Reverend gentleman before the photograph was taken.

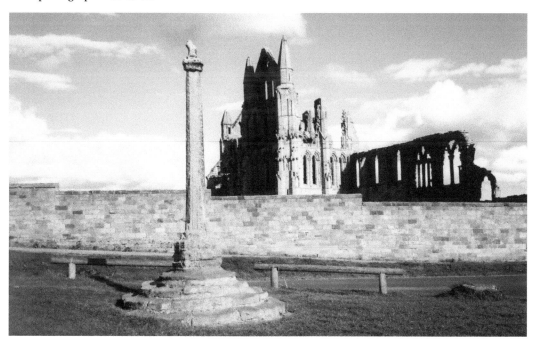

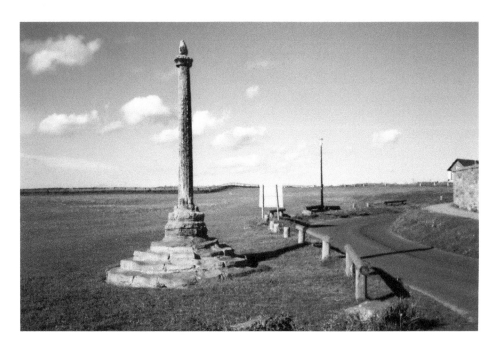

The Abbey Plain Cross

On the Abbey Plain stands a fourteenth-century shaft on six steps. The panelled shaft with its capital is intact but the head has been mutilated. It is supposed that this was a griffin, similar to two that adorned the Abbey House gate piers, which are now weathered beyond recognition. The griffin was the emblem of the Cholmley family. The purpose of the cross has been hotly debated over the years. Some believe it was a market cross, others a cemetery cross. Below, the author as tour guide on the open-top tour bus with Ronnie Harland as driver.

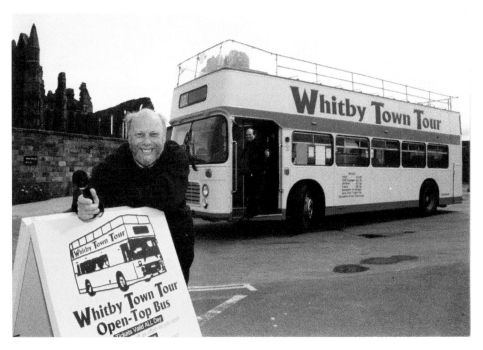

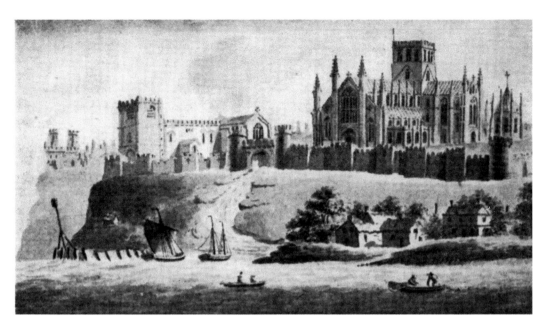

Whitby Abbey in 1320

So much have visitors enjoyed the vista of Whitby Abbey that before the advent of photography, artists were creating engravings and likenesses that are undoubtedly the earliest record of these enigmatic ruins. Above we see an image of Whitby Abbey as it may have appeared in 1320 during the time of the Normans, which shows it has a defended, walled Abbey. Below is an engraving by Samuel Buck, published in 1711, and thought to be the earliest image of Whitby Abbey. This shows the north side, which has all but disappeared today.

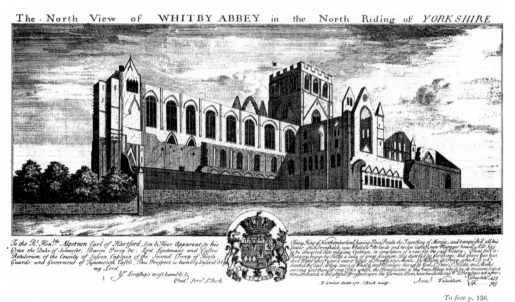

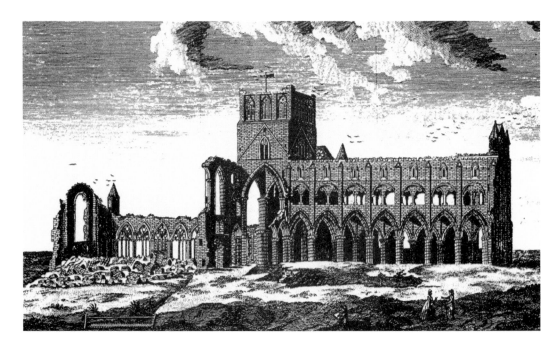

South-East Prospect of Whitby Abbey

Another eighteenth-century engraving showing the south-east prospect of Whitby Abbey in 1773. The central tower still stands, and it is possible to see the roof line on the tower that would have covered the fallen transept. Below, is a wood-cut by the famous engraver Thomas Bewick, taken from the title page of an eighteenth-century printed play on the subject of Whitby Abbey. Although not as fine as a steel engraving, it nevertheless gives an important glimpse of how the Abbey ruins stood before restoration in later centuries.

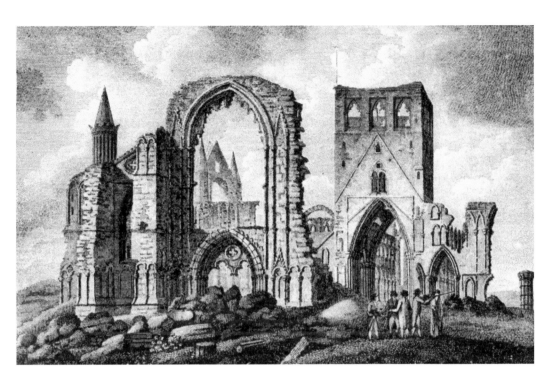

Whitby Abbey from the West

Two almost identical general views from the west in around 1789, before collapse of central tower in the summer of 1830. The figures in the foreground are there to provide a sense of scale, but in reality they are too small to be an accurate guide to the size of the monastic ruins. However, the insertion of figures demonstrates that the ruins were already an important tourist attraction, with artists visiting and the gentry picnicking in the grounds. The lower view is an aquatint by Francis Grosse.

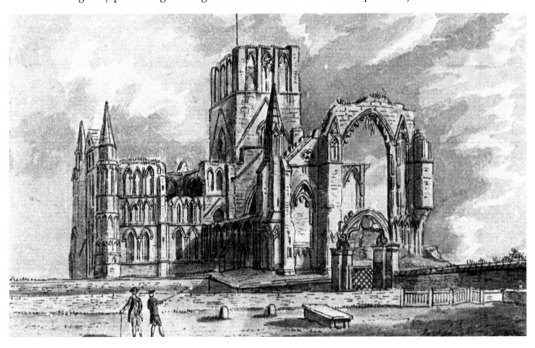

WHITBY ABBEY FROM THE WEST BEFORE THE TOWER FELL IN 1830.

Whitby Abbey from the West

Another fine view of the Abbey ruins from the west, but this time showing the south-west aspect of the chancel and the almost-complete north transept. The view below, a watercolour executed around 1820, is by John Buckler, and shows the north walls of the north aisles of nave and choir, with north transept and tower. The grounds at this period were unkempt, and no archaeological excavations had taken place – the ruins themselves were merely considered a romantic backdrop, and their importance as an historical monument had not been appreciated.

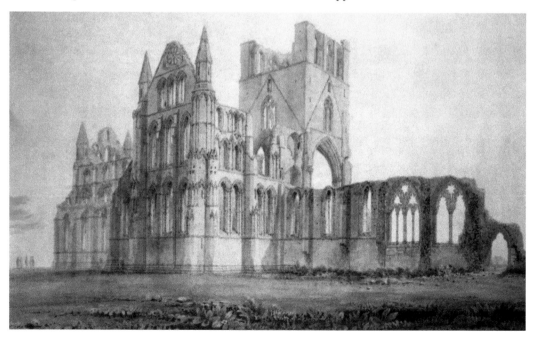

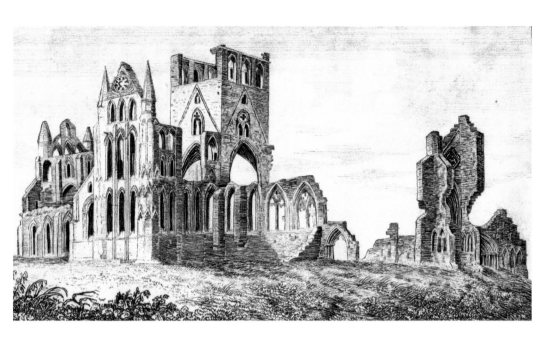

Whitby Abbey Ruins

Below, an engraving of the Abbey ruins, dating from the eighteenth century, shows the west front, tower and north transept *c.* 1790. The scale of this engraving somehow does not seem correct and the artist appears to have portrayed the ruins longer than they are. Meanwhile, above we see an engraving by John Bird, from his own drawing, which appeared in Revd George Young's two-volume *History of Whitby* – Vol. 1 published in 1817. This view shows the north transept and remains of the west end, which appears more ruined by this date.

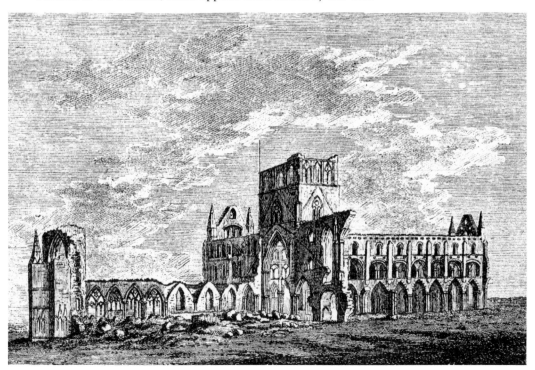

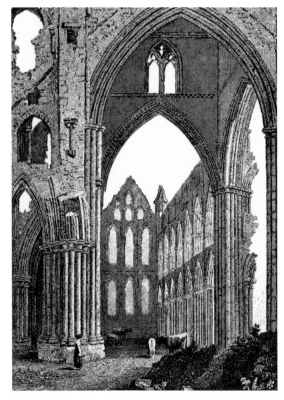

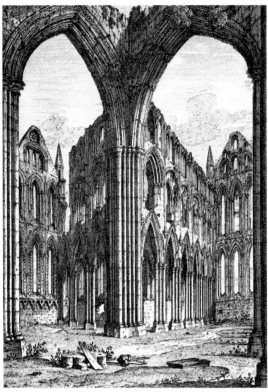

Under the Tower, Whitby Abbey
Two engravings of mid-nineteenth-century date showing the crossing under the great tower of Whitby Abbey before it fell in the summer of 1830. The upper image is from a drawing by Gastineau, looking toward the east, clearly showing the sad state of the grounds. Below, an unusual engraving from under the tower looking east into the north transept. Following the fall of the tower, a letter appeared in the town: '...we are at a loss to conceive how it could have escaped the observation of those, who, one might suppose, would have manifested an especial regard for its preservation. The proprietor, it is true, has removed to some distance from the town, and seldom honours his seat at the Abbey with his presence; but can we think that if he had been aware of the danger which threatened the venerable pile, that has for centuries imparted such an air of dignified antiquity to his ancestral domains, he would thus insensibly have suffered it to sink, without the slightest effort on his part to rescue it from destruction... we cannot pass on without regretting the extreme inattention to the state of the building, which of late years has been but too apparent in every quarter... that it must soon cease to be the glory of Whitby, and a guide to the mariner as he traverses the distant ocean...'

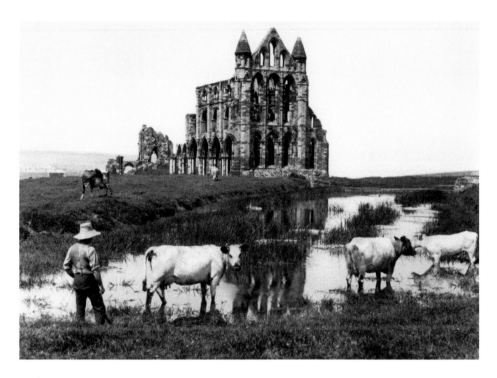

East Front, Whitby Abbey

The foundation of Whitby Abbey was in part due to the fulfilment of a vow made by the Christian King Oswy, of Northumbria, before the Battle of Winwaed in AD 655, against the heathen King Penda, of Mercia. Oswy undertook, in the event of victory, to establish twelve monasteries, six in the kingdom of Deira and six in Bernicia. Whitby Abbey was one, and work began in AD 656 on a double monastery of men and women, which formed a characteristic feature of the early Anglo-Saxon Church.

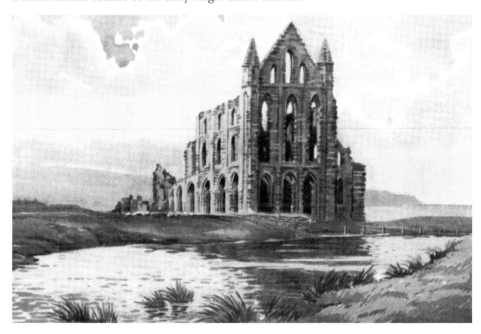

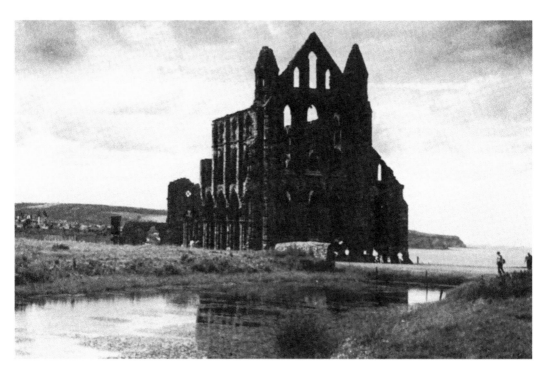

Whitby Abbey, East Front in Autumn

Under Princess Hild – popularly called St Hilda, although she was never canonised – Whitby Abbey rapidly grew and achieved a high reputation both for piety and for ecclesiastical training. It figures largely in Bede's *History of the English People*, and in time it became the burial place for members of the royal house.

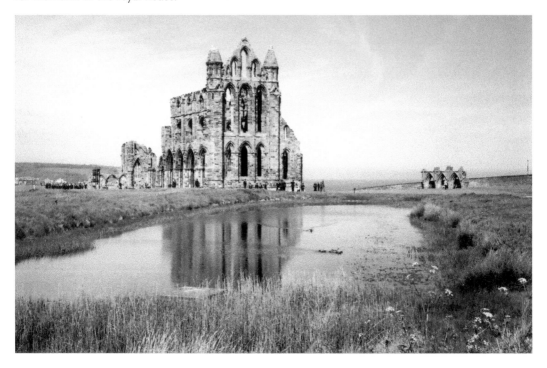

The Synod of Whitby

Two events stand out in the Abbey's early history. The first, the Synod of Whitby, took place in AD 664 and was convened by King Oswy to settle a number of differences that had arisen between the Roman and Celtic elements of the English Church. In particular there was a division between the two parties as to when Easter should fall. This was resolved in favour of the Roman Church, and indeed, even today the method evolved is still used to calculate the Holy Feast Day. The second involved Caedmon, the most celebrated of the vernacular poets of Northumbria, who was a farm worker on the lands of the Abbey during the days of Hilda, and known to be illiterate. Following a vision or dream, he began to compose verse, his most famous work being the 'Hymn of Creation', which was the first English poem to be written down. Sadly, the Anglo-Saxon Abbey was destroyed by the Danes in AD 867 and the site of the ancient monastery laid waste for more than two hundred years.

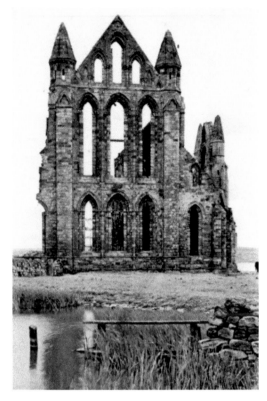

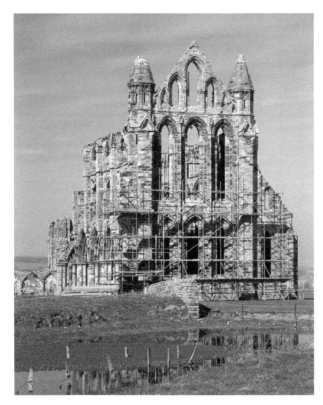

East Front, Whitby Abbey
Whitby Abbey was re-founded
as a priory about the year 1078
by Reinfrid, a monk from the
Benedictine Abbey of Evesham,
in Gloucestershire. William de
Percy granted the site for the new
priory, which was elevated to the
status of an Abbey in the early
twelfth century. Not many years
later it was recorded that 'thieves
and robbers, by day and night
laid that holy place desolate.
In like manner, pirates void of
all compassion landed there,
and came and plundered the
monastery.' Above we see the east
end, built *c.* 1220, under repair
during 1997.

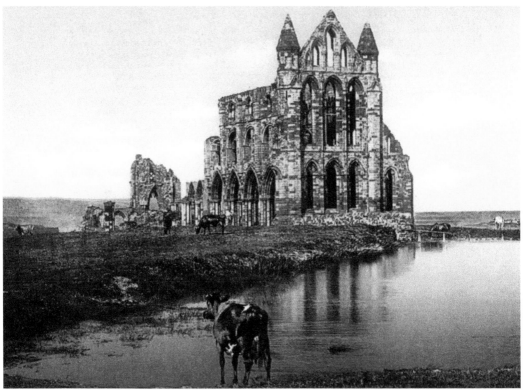

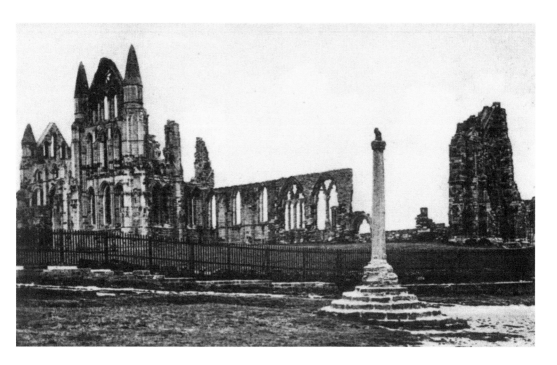

Whitby Abbey from the South

By the end of the twelfth century Whitby Abbey supported about forty monks, and for the next two centuries the Norman Abbey flourished. However, by the fourteenth century it was in decline. By the time of the Suppression of the Monasteries by King Henry VIII from 1539 there had been thirty-three abbots. The last, Henry de Vall, surrendered it to the king when the Abbey was valued at £437 2s 9d, but the Abbey church, although robbed of its lead roofs, was suffered to remain intact while many others were pulled down.

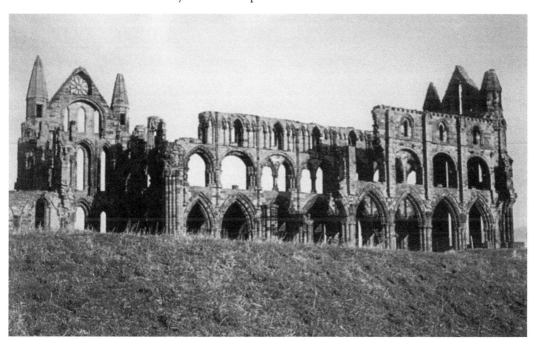

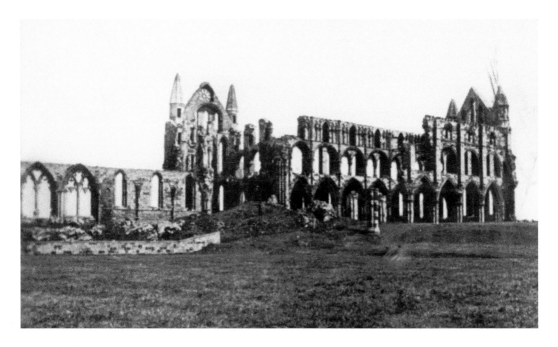

Whitby Abbey from the South

The south transept, which largely collapsed in 1763, has now almost entirely disappeared except for the foundations, some bases and one pier of the main east arcade. When the transept was rebuilt around 1230–40 it was extended south over the passage adjoining the shorter transept of the Norman church. Against its southern end stood the chapterhouse and above this was a large fourteenth- or fifteenth-century window as shown in an early engraving. The single surviving pier of the arcade is similar to those in the presbytery.

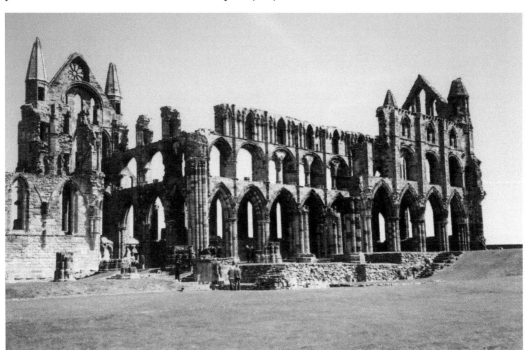

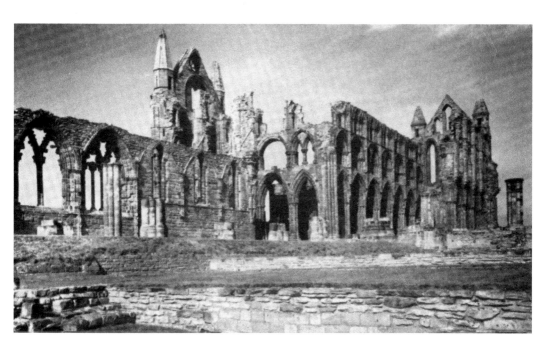

General View of Church from South-West

The nave, which fell in 1762, is represented only by an appreciable portion of the outer wall of the north aisle, a reconstructed pier, the stumps of the other piers and the scanty remains of the west front. The first three bays of the aisle wall belong to the mid-thirteenth century and each have a lancet window with banded internal shafts. Dividing the bays are grouped vaulting shafts on which rest the springers of the former ribbed vault. The rest of the wall to the west dates from the fourteenth century.

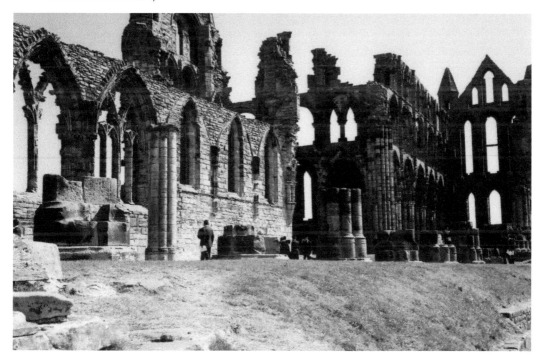

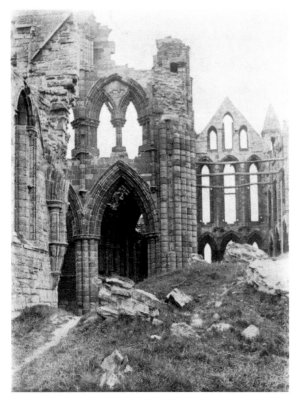

Presbytery Looking East

There is no documentary evidence for the exact date when the rebuilding of the Abbey church began, but the style of the building, a mature Early English Gothic, suggests that it was probably started in the late 1220s under Abbot Roger of Scarborough (abbot from about 1223 to 1245). It replaced an earlier Romanesque church at Whitby, which had a much shorter eastern arm or presbytery. The line of its walls is marked out in the turf. In medieval England most of the grandest monastery churches were Benedictine houses, like Whitby. Benedictines were rich and a fashion developed, starting at Canterbury in the 1130s, for demolishing short presbyteries and building much bigger ones. It was usual, in rebuilding an eleventh- or twelfth-century church, to start at the east end and work westwards. Later generations often went on to replace the twelfth-century nave as well, as happened here at Whitby. The presbytery is seven bays long and stands to its full height with the shell more or less complete. Under the lancet windows stood the high altar, and notches in the columns indicate that timber screens divided the space.

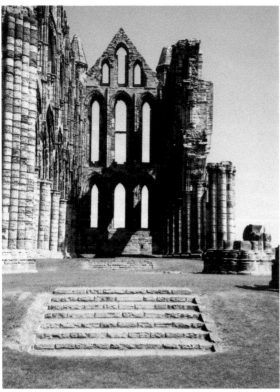

North Aisle of Chancel

The north aisle is largely intact and has a single lancet window (below) with side-shafts in the east wall and in each bay of the north wall. The ribbed stone vault survives except in part of the fourth bay from the east, where the vault springs from shafts against the outer wall, standing on corbels at the level of the window sills. The outer wall of the south aisle has gone, but one jamb of the east window remains, together with some of the northern springers of the stone vault, which was similar to that of the north aisle. Adjoining the third bay of the aisle are the foundations of the former sacristy, added later in the thirteenth century. Walking along its length it is easy to imagine the great Abbey in its zenith; you can almost hear the monks chanting in harmony and smell the incense.

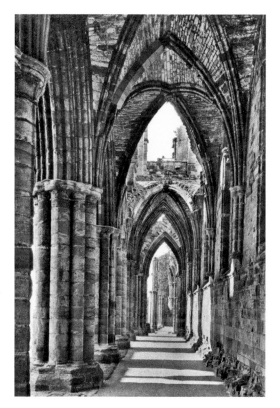

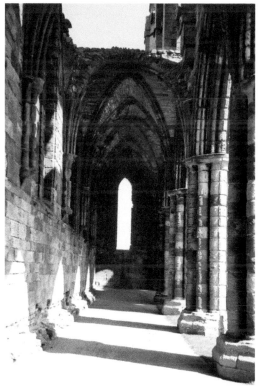

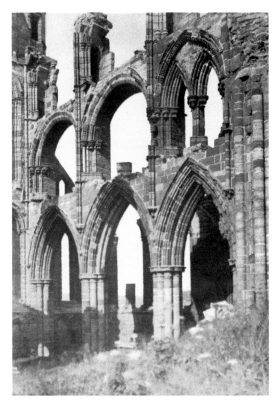

The Venerable Bede

Bede (673–735), was given into the care of Bishop Benedict Biscop, Abbot of Wearmouth, as a child. Other than a short account of himself, or what others wrote, we know little of his life until his last hours. With the exception of a few visits, Bede spent all his life at Jarrow. His lasting achievement was the compilation of his *History of the English Church and People* in which he writes, 'That Hilda was no sooner established Abbess of Streanshalh, than she put the monastery there under the same regular discipline that she had practiced at Hartlepool, and taught the strictest observances of justice, piety, charity, and other virtues; and particularly of peace and charity, it being her daily custom with great devotion to pray for the peace of her nation. She copied after the example of the primitive church; so that in her monastery no person was rich, nor any poor, but every thing was in common to all, no one there having any real property. Her prudence was so great, that not only indifferent persons, but even Kings and Princes, as occasion offered, deigned to ask and also to receive her advice.'

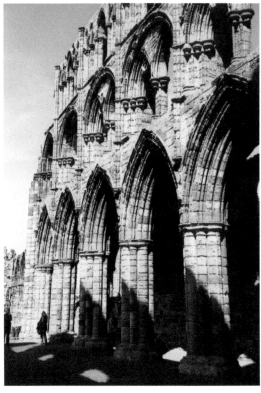

The Early Abbey at Whitby

The first establishment at Whitby was one of a double monastery of men and women, which formed a marked feature of the early Anglo-Saxon Church and, in this instance, was presided over by an Abbess. Little is known of the precise form of the early monastery. The site would have been enclosed by a ditch and bank, or hedge of thorns and within the enclosure stood the church or churches of the monastery. The actual church would have been quite small in size and was often provided with side chapels. Grouped around the church or churches stood the cells of the inmates and one or two larger buildings for common use such as the refectory, a schoolhouse and a guest house. One at Whitby measured some 47 feet long by 18 feet wide. The individual cells measured around fifteen to twenty feet long and about ten to twelve feet wide. Many had a small hearth for a fire. The site was well drained using an elaborate system of stone-lined drains. Wells were fairly numerous. There was a burial ground in this instance, where the royal bodies of King Edwin and other of his family. Finds within the cells include loom weights and undoubtedly the inmates were responsible for creating their own garments.

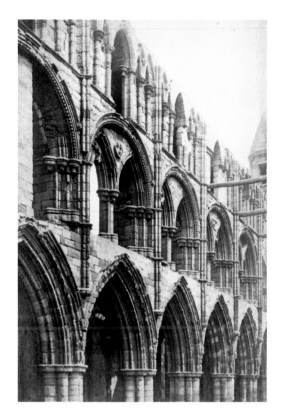

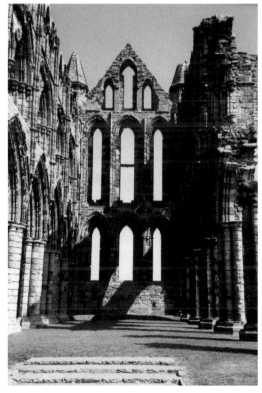

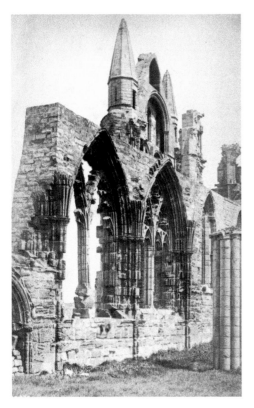

A Monk's Life

The privilege of being admitted a monk was so much valued that it was frequently procured by interest or by money. It could not be attained in any instance without passing through tedious forms, adapted to try the patience and perseverance of the candidates. They remained for a year in a state of probation, during which time they were called Novices, and usually lived in a house or office appropriated for their reception, under the discipline of an experienced monk called the Master of the Novices. This Master had also under his tuition the boys presented to the monastery by their parents, and educated there, to whom the name 'Novice' was likewise given. These youths were taught to sing and employed as choristers under the direction of the precentor, but could not become professed monks under eighteen years of age. The discipline of the Benedictines was extremely strict, requiring from the monks and inferior officers the most abject submission to their superiors. A chapter was held every morning, when note was taken of every transgression or neglect, and great offences were punished with mortifying penances and even with corporal chastisement. The unruly were sometimes removed to the cells; the incorrigible were, after sufficient trial, degraded and expelled.

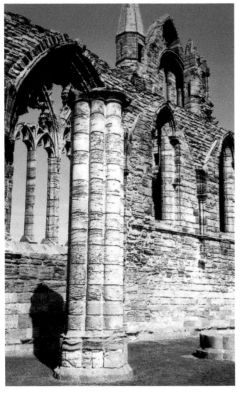

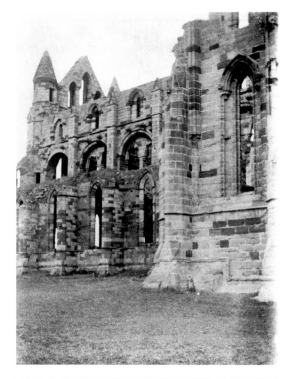

A Monk's Life Continued

The dress of the monks of the Benedictine order is known to have been black and thus they were called 'black monks'. It consisted chiefly of a long, loose robe or gown, with a hood or cowl of the same material. Among the monks (and nuns also) before the Reformation, luxury in dress was a prevailing evil. Luxury in food prevailed to a still greater degree. Loud complaints were made on this subject, and the accounts of the expenditure of our monks testify that such complaints were not unfounded. They had abundance of wine, used immense quantities of ale or beer, had all varieties of flesh, fish, and fowl, and almost all sorts of fruits, spices, and sweetmeats. Nor were they destitute of amusements, as appears from the sums which they gave to minstrels, harpers, pipers, players, and others who contributed to their pleasures. On the whole, they cannot be charged with monkish austerity. The chief employment of the monks, agreeable to their profession, consisted in religious 'exercises'. They had prayers seven times a day, at stated hours, and a number of additional services on Sundays and festivals.

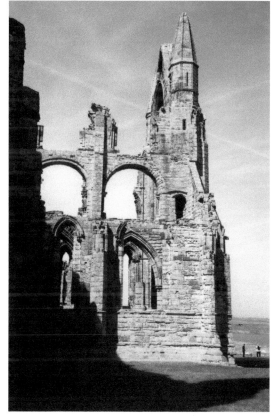

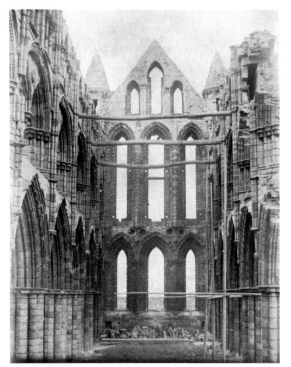

The Architecture

Whitby Abbey is a magnificent example of English Gothic architecture built over a long period. However, its eastern arm represents a fairly specific phase in the development of the style in England, between around 1220 and 1250. Gothic architecture, based on the pointed arch, originated in northern France in the mid-twelfth century. It evolved from the heavier Romanesque style with its thick walls, semicircular arches, and relatively small windows. In the 1140s, Abbot Suger of Saint Denis, north of Paris, had a vision of a new architecture in which light represented divine truth. The new style progressively became higher and lighter, with thinner columns, larger windows, and more elegant proportions. The style was first brought to England in the late twelfth century, probably by French masons, but by 1200 English masons were making it their own. Master masons designed and ran building projects, trained apprentices, and moved from church to church. We only know a few of their names, but the 'signature' of individual masters can be traced in details such as the shape of columns, the moulding profiles, and the carved ornament. The upper photograph by Sutcliffe shows the presbytery walls being supported with timber to stop them falling inward.

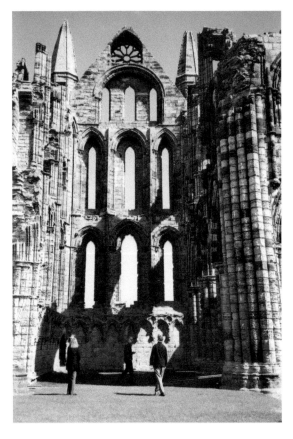

South Aisle, Chancel

On the piers are traces of the fixing of former timber screen work and there is a large cupboard recess in the north wall. On the first column from the north of the main arcade is a much-weathered incised inscription of late thirteenth- or early fourteenth-century date, which is thought to read as follows, the words in brackets being now lost: JOHANNES DE BRVMTO QVONDAM FAMVLVS [DEI, IN HOC ALTARI FVNDAVIT SERVICI] VM IN PERPETVVM IN HONOREM BEATE MARIE (John of Brumpton, sometime servant of God dedicated an altar to the Blessed Mary there).

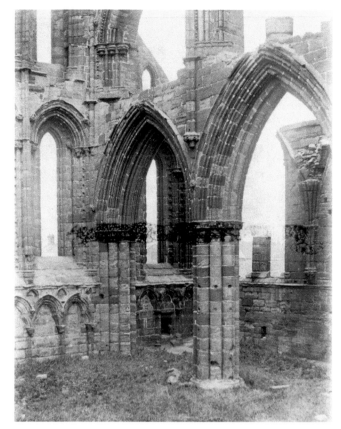

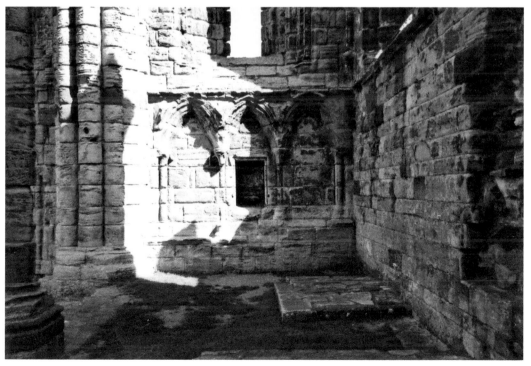

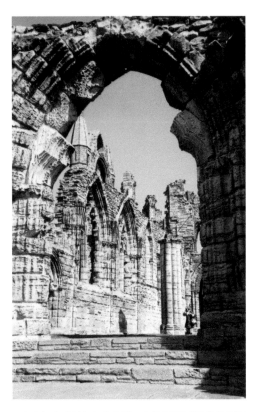

A Monk's Funeral

The ceremonies attending the funeral of a monk are too tedious to be fully enumerated. Suffice to say, if the deceased died early in the morning, he was buried the same day; if not, the day following. Among the apparatus of superstition used at the grave were tapers, candles, holy water, a cross, a censer with incense, and a written absolution, which was read aloud to the brethren, and then laid on the breast of the deceased, as his passport to heaven. For thirty days, Mass was said for his soul, his grave was daily sprinkled with holy water, and his allowance of bread, beer, and meat, was given to the almoner to be distributed to the poor. The anniversary of his death was commemorated by a similar distribution, as well as by appropriate religious rites. The services for the death of an abbot, were of course more numerous and lengthy. It was not unknown for the service, or at least the distribution of alms, whether for an abbot or a monk, to be continued a whole year. If they belonged to the governing chapter, but resided in one of the cells or elsewhere, the time for a private monk was thirty days.

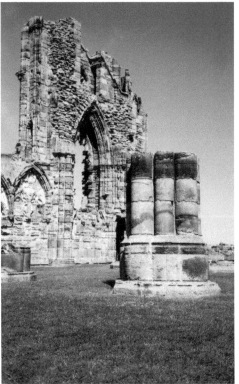

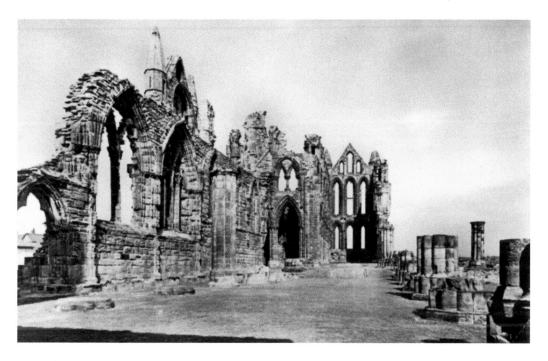

The Foundations of the Earlier Church

An early photograph of the Abbey shortly after it was taken into the guardianship of the Ministry of Works, later to become English Heritage. Previously, many of the walls were supported and braced with substantial timber beams to stop them falling. A great deal of the internal space was covered by fallen and overgrown masonry, which, when cleared away as below, revealed many lost features, such as the rounded apse of the earlier church marked out in stone. This shows that the church was only half the size of the present one.

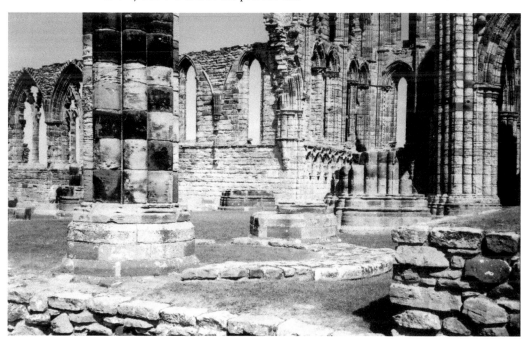

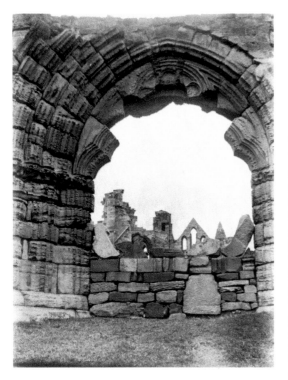

The West Door

The west front dates to the beginning of the fourteenth century with later alterations. The main west doorway originally had a central pier dividing its two trefoil-headed openings, with a quatrefoil above. It is flanked internally by smaller wall-arches with blind tracery. The general appearance of the front before much of it fell in 1794 can be seen from the Gibson aquatint of 1789. The great fifteenth-century window was perhaps of eight transomed lights and remains of the fourteenth-century wall passage at its base may still be seen. The inserted fifteenth-century window in the west wall of the aisle still partly survives and above it is a diagonal window enclosing four quatrefoils. The lower part of the front has trefoil-headed wall arcading. At some date prior to 1920, the opening of the west door we can see was partially blocked by rough masonry. Thankfully, this has been removed to allow a glimpse along the entire length of the nave. Interestingly, the nave is not in alignment with the presbytery and transept, misaligned by some four degrees. There is no parallel to this in any other major English medieval church.

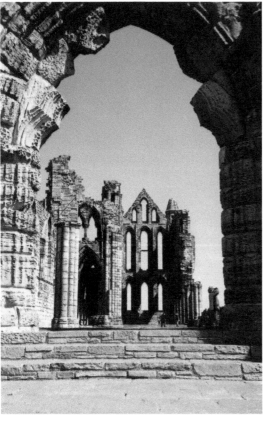

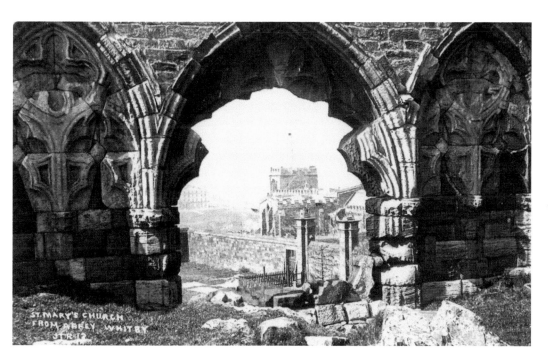

Parish Church from the Abbey

Two views through the west door: above in 1913 and below in 2011. This fourteenth-century decorated Gothic arch was constructed during the final stage of the Abbey's development prior to its eventual destruction in 1539. The final development was the extension to the nave at the western end and the style was later Decorated Gothic. This arch, used by Ross for the above photograph, received a direct hit during the 1914 German naval bombardment of Whitby but was subsequently restored.

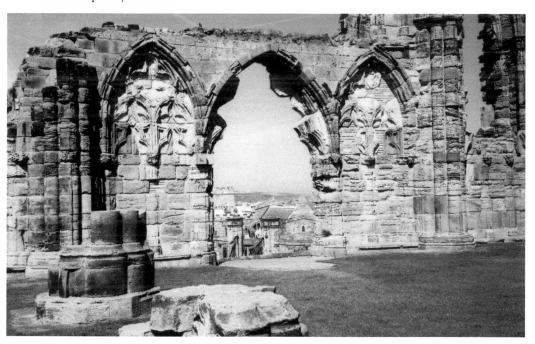

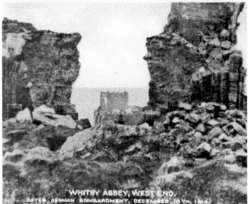

WHITBY ABBEY, WEST END.
AFTER GERMAN BOMBARDMENT, DECEMBER 15 TH 1914.

West Door, Detail

Above, an unusual postcard showing the west door looking toward St Mary's church before the bombardment of 1914 when a direct hit shattered the arch, inflicting the damage seen in the lower half of the view. After the war, the west door archway was rebuilt as complete as the Ministry of Works could ascertain. What fascinates me about ruins is the weathering of the stone into fantastical shapes by the constant winds on the headland. One of the best places to observe this phenomenon is in the nearby churchyard of St Mary's.

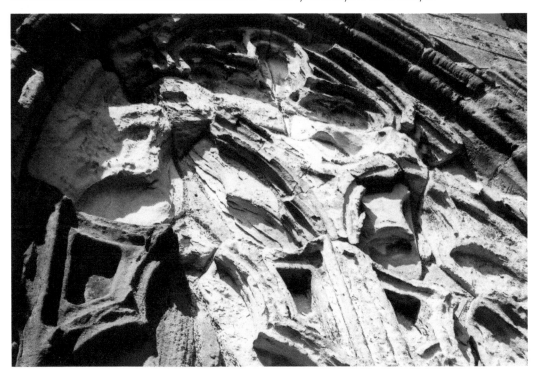

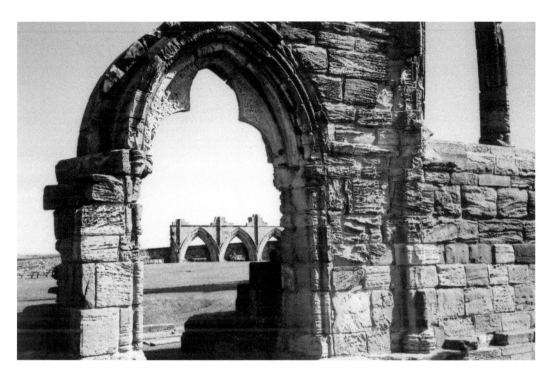

Nave Arcades

Viewed through the doorway in the north wall of the nave, re-erected against the north wall of the enclosure are three and a half bays of moulded arches, with vaulting shafts between them and parts of the storey above. These are the remains of the nave arcades, which were found, fallen but complete, during the excavation and possibly date to the fifteenth century. They were placed here by the Ministry of Works (now English Heritage) around 1920 when they took over guardianship of the ruins and began a comprehensive plan of archaeological investigation.

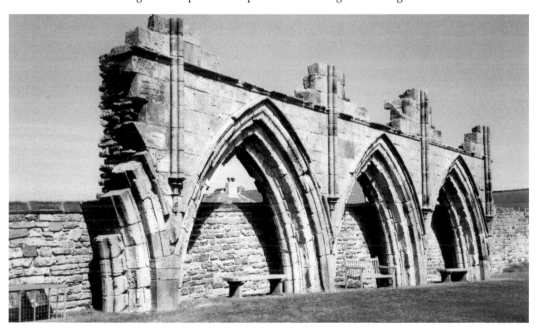

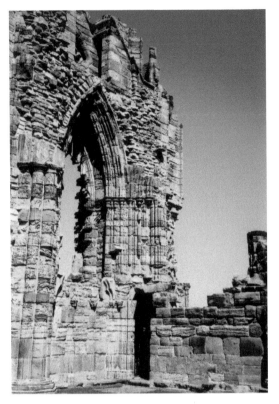

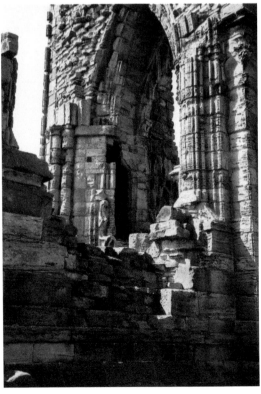

The Life of Reinfrid

The story of Reinfrid begins in the year 1074 when a presbyter named Aldwin came to Evesham Abbey and persuaded Elfwine, a deacon, and Reinfrid, a monk of good reputation but of no learning, to join him in a journey north to rebuild some of the ruined monasteries. They first settled at Monktown on the north bank of the Tyne, but as the place did not meet their expectations they moved to the ancient monastery at Jarrow and built themselves huts among the ruins before erecting a temporary place of worship. Not content with refounding one monastery they resolved to establish others. Reinfrid travelled south to revive the ancient monastery of St Hilda.

He had formerly been a soldier in the Conqueror's army, and being with him in his Northern Expedition (1069), he had turned aside to visit the ancient Streonshalh, where his heart was greatly affected at beholding its ruins and he took up the life of a monk. Having seen the ruins where about forty cells or oratories stood as bare walls and empty altars, he returned to Whitby and set up in the ruins and repaired some part of the church for public worship. It is not known for certain when Reinfrid settled at Whitby but it could not be later than 1078 when he was joined by Stephen of Whitby who became Abbot of York.

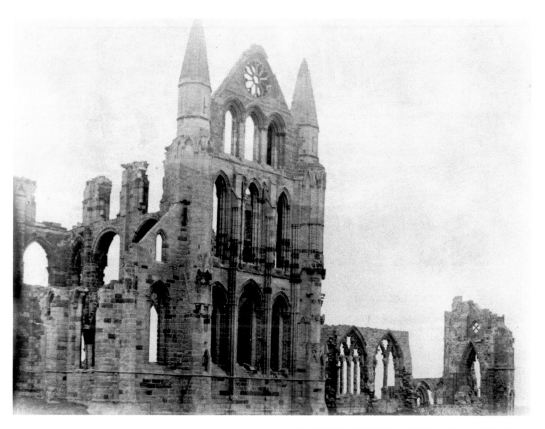

The Transept

The transepts are the short arms of the church and gave it its cross shape; the place where they intersect is called the crossing. At Whitby, as at many great English churches, the crossing was capped with a square tower. Transepts allowed for extra side-chapels with altars that could be separately dedicated. At Whitby, an eroded late-medieval inscription in the north transept once stated, 'John of Brumpton, sometime servant of God dedicated an altar to the Blessed Mary there'. Masses could be said for the souls of patrons, who paid for this important service.

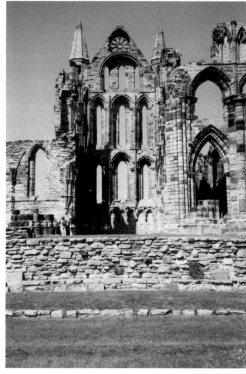

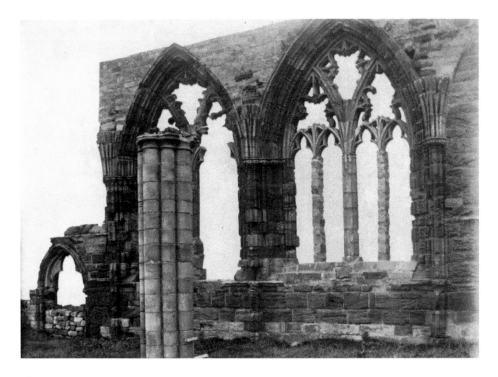

The Nave Remains

The first three bays of the aisle wall of the nave belong to the middle of the thirteenth century. Dividing the bays are grouped vaulting shafts on which rest the springers of the former ribbed vault. The rest of the wall to the west dates from the first quarter of the fourteenth century. The fourth and fifth bays of the aisle each have a window of four trefoiled lights with shafted splays and mullions and admirable tracery. In the sixth bay is a doorway of the same period with a moulded and trefoiled head.

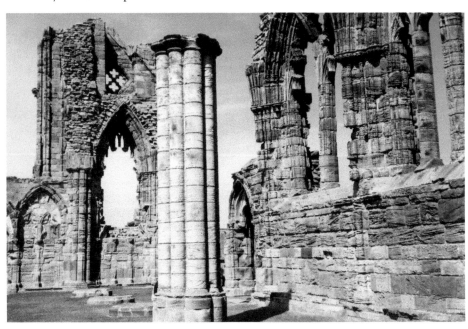

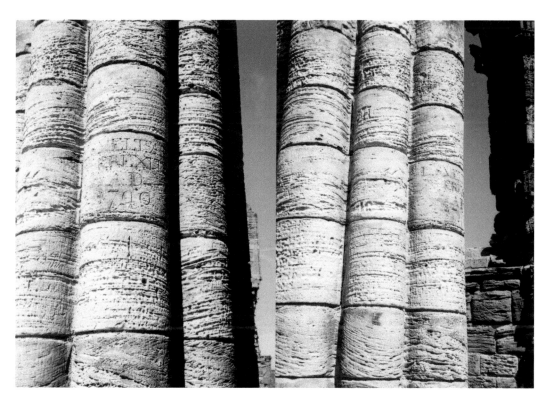

Graffiti, Whitby Abbey

One interesting aspect of touring the Abbey ruins is spotting the amount of graffiti that has been carved into the stonework. Such an act today would be classed as sheer vandalism, and could no doubt lead to a fine if a culprit was apprehended by staff and reported to the police. Yet somehow, graffiti from the past seems part of the history; there are dated inscriptions of 1790, and undoubtedly Christian symbols from a much earlier time. Robbers destroyed one inscription, behind which was believed to be hidden treasure.

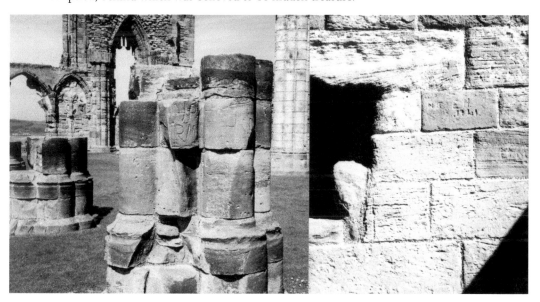

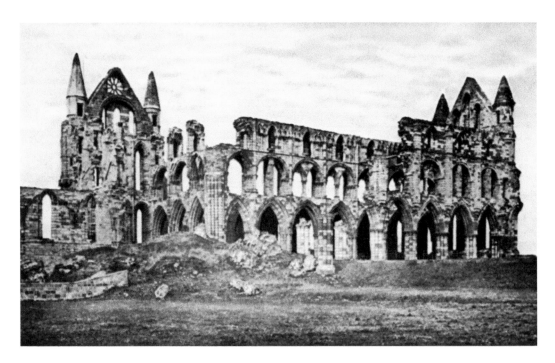

The Abbey Ruins from the South-West, 1901

The architecture at Whitby is similar in style to work at the northern monasteries of Rievaulx and Byland (both Cistercian) and Kirkham and Hexham (Augustinian), although they are probably a little earlier. Abbot Roger, who commissioned the rebuilding at Whitby, may have been motivated by a spirit of competition with these and other houses. The likely sources for its design, though, were the transepts of York Minster, rebuilt between about 1225 and 1255 by Archbishop Walter de Grey, and the grandest church-building project in the north of England at the time.

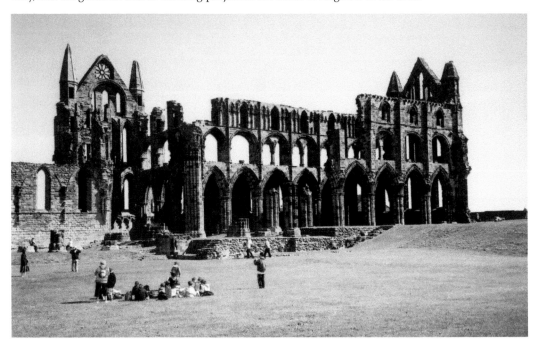

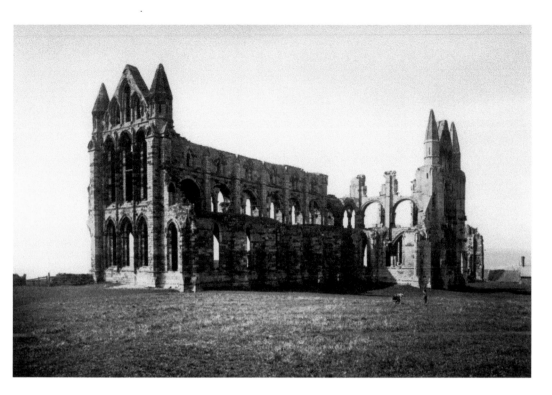

The Abbey Ruins from the South-West

This is another of the Sutcliffe view of late-nineteenth-century date, taken around 1898 before the site was cleaned of all fallen ruins. This textbook view shows clearly the north elevation, the triforium, clerestory and the north transept. In the modern photograph below, taken in July 2011, it is possible to see that the church was built on two different levels and, unusually, has steps leading up to the crossing, which is not often seen in major English medieval churches.

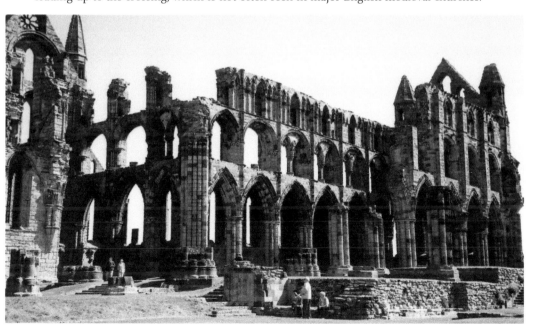

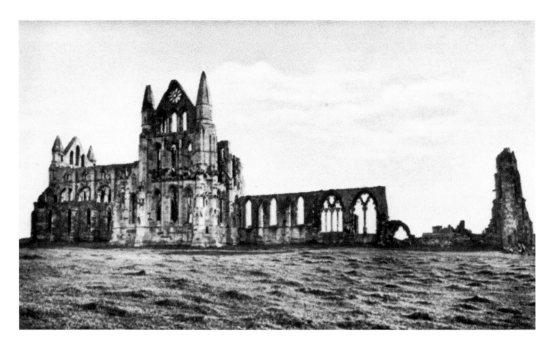

Abbey Ruins from North-West

When John Wesley visited Whitby he wrote, 'I walked round the old Abbey which, bore with regard to its size (being I judge, one hundred yards long) and the workmanship of it, one of the finest... ruin in the kingdom.' Another visitor, Dr W. A. 'Tom' Bradley, who became headmaster of the grammar school here, wrote humorously in 1891, '...St Hilda seems to have knocked about the place a great deal. They fixed her name up everywhere. There are St Hilda inns, St Hilda villas, the St Hilda Music Hall, St Hilda oyster stalls... maybe St Hilda pawnshops for anything we can tell...'

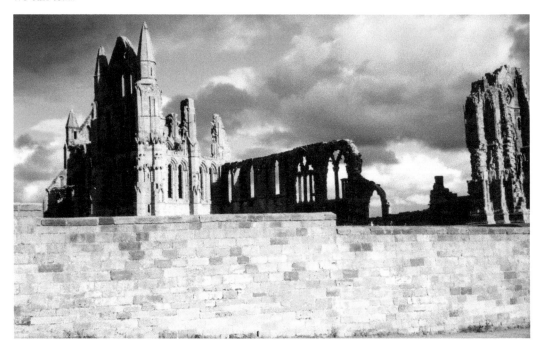

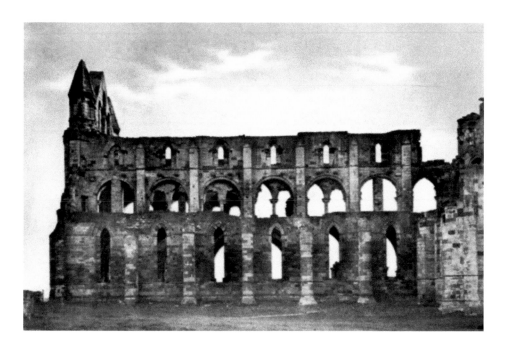

North Side of Choir, Exterior

The richly moulded arches of the aisles, with their distinctive 'clustered' columns, supported the triforium above. This was an arcaded gallery, which would have been dark as there were no windows at this level. Inside, its arches would have been adorned and subdivided with colonettes of a dark, polished limestone or marble, which are now missing. Above this is the clerestory, with two blind arches to either side of a single-light window in each bay. The Abbey church had a timber roof, probably lined with a boarded ceiling with imitation vaulting ribs.

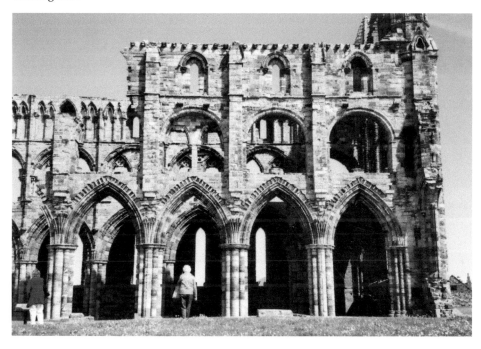

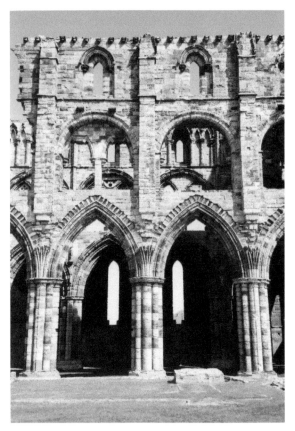

The Clerestory Sculptures

The height of the church was accomplished in three orders: at the bottom was the presbytery and aisles with large pointed arches; next came the triforium and crowning all the clerestory level, which would have been an exterior wall, with the roof of the church being supported on corbels above the round-head windows.

The purpose of the sculptures, often called gargoyles, was two-fold: to act as drains and throw rainwater clear of the walls, and to ward off evil and earthly spirits that might be prowling about the church.

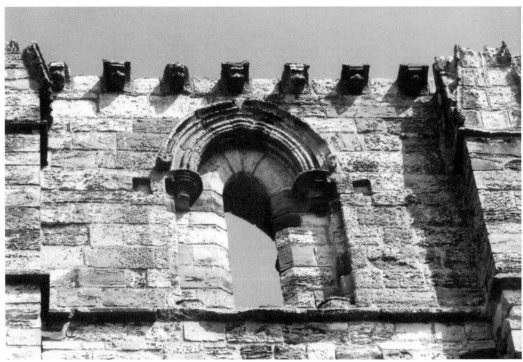

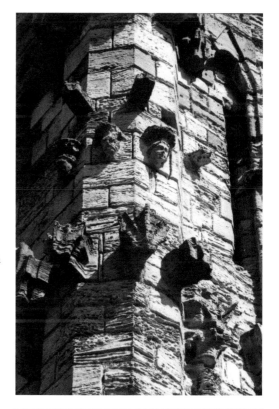

Sculptural Detail, North Transept

In the upper image, we see details from
the face of the north front of the north
transept, which are more elaborate than
those of the eastern arm of the church, with
panelled faces and niches at the base of the
main buttresses. Many of the sculptures
are mythological beasts, but there are a
number of human figureheads and these
may represent donors of gifts to the Abbey.
Below, internally the north transept has
a wall-arcade of moulded trefoiled arches
along its north and west walls with foliage-
capitals to the shafts and quatrefoils in the
spandrels. 'Quiet, then, is the first step in
our sanctification' (St Basil). The object, life
and reward of monasticism was '*summa
quies*': the absence of all excitement,
whether sensible or intellectual, which
might disturb the central contemplation
aimed at the achievement of the heavenly
Sabbath. The religious house was the home
of silence, voices were only to be raised in
prayer and praise, silence (apart from the
measured words of scripture coming from
the reader) was maintained in frater, and
silence brooded over the whole house from
Compline to the office of Mattins.

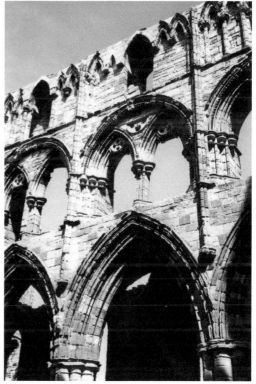

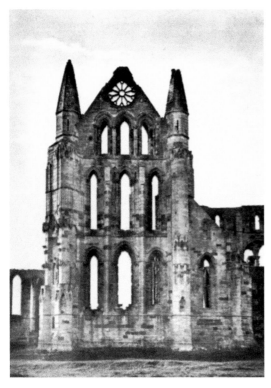

Termination of North Transept

The north transept still stands almost to its full height and is generally distinguished by a freer use of foliage-carving. Internally, it has a wall-arcade of moulded trefoiled arches along its north and west walls, with foliage-capitals to the shafts and quatrefoils in the spandrels. The arcade of three bays, opening into the east aisle, is generally similar to that of the presbytery. The triforium and clerestory above were also generally similar. The north front has three tiers of lancet windows, three in each tier, similar to those of the east front, except that the shafts have foliage-capitals and the lancet windows of the top tier are of one height, enclosed in an internal wall-arch. In the gable is a three-sided traceried window. The buttresses of the north front are more elaborate than those of the eastern arm of the church and have panelled faces and niches at the base of the main buttresses. The west wall of the transept has wall-shafts between the bays and a pair of lancet windows in both the two northern bays; these have foliage-capitals and 'dog-tooth' ornament.

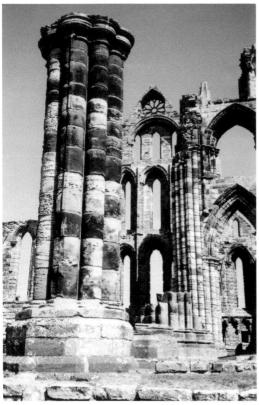

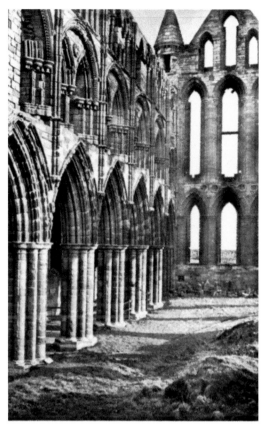

North Arcade of the Presbytery

In medieval England most of the grandest monastery churches were Benedictine houses, like Whitby. The Benedictines became a powerful and rich order, and a fashion developed, starting at Canterbury in the 1130s, for demolishing short presbyteries and building much larger ones. It was usual, in rebuilding an eleventh- or twelfth-century church, to start at the east end and work westwards: later generations often went on to replace the twelfth-century nave as well, as happened here; the line of the walls of the earlier Romanesque church at Whitby are marked out in the turf for comparison.

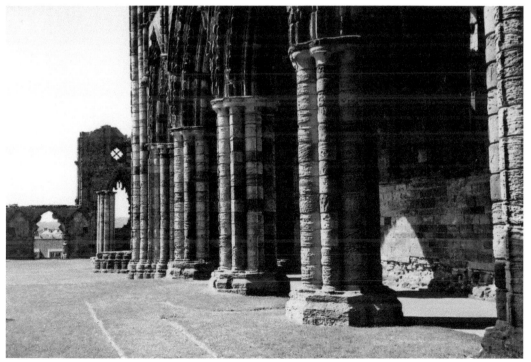

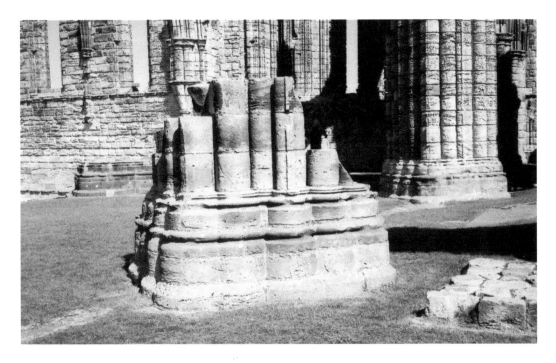

The Crossing

The massive crossing piers seen above, made up of many columns, carried a short lantern tower. This collapsed on 25 June 1830, but we have good drawings of it by the artists John Buckler and his son John Chessell Buckler (see page 19), which show that architecturally it was in the Early English style of the mid- to late-thirteenth century. Central towers and lanterns are rare in Continental Gothic churches, and this was one of the many aspects in which English masons tended to deviate to create the inimitable style of English church architecture.

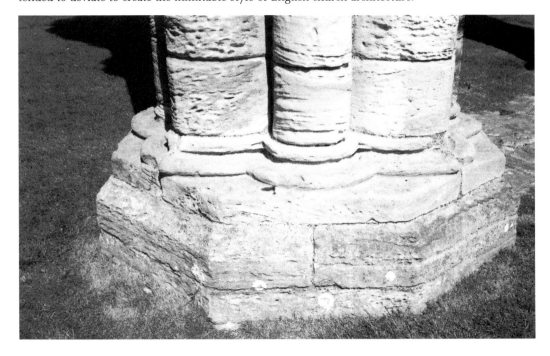

The Lay Brothers

Besides the offices held by the monks themselves, there were several others that were filled by laymen. The Head Cook position, or Kitchener, was from the time of Abbot Richard I held hereditarily, at four shillings per annum, by Robert Cook and his sons. In this department, there was also the common cook, who perhaps prepared for the other servants and for strangers, the abbot's cook, and the cook of the infirmary. The office of the porter, who had usually a sub-porter under him, was a charge of considerable importance. There appear to have been numerous pages and valets to attend on individual officers, as the abbot, the prior, and the cellarer, but there were some who had particular departments allotted to them, as the page of the hall, and the page of the stable. There is mention of the baker, the brewer, the barber (*barbitonsor*), the miller, the huntsman, the poulterer, the swineherd, and others who resided outside the gates of the monastery as some had wives and children. The baker, poulterer, miller, and huntsman had horses allowed them. Then there was the client of the fish-house, who had charge of a most important branch of the revenue of the monks, and received a large salary.

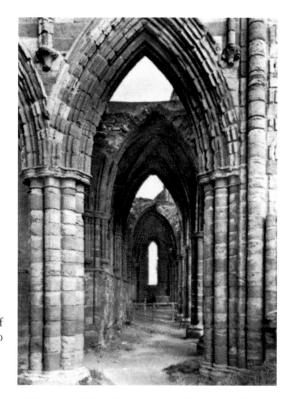

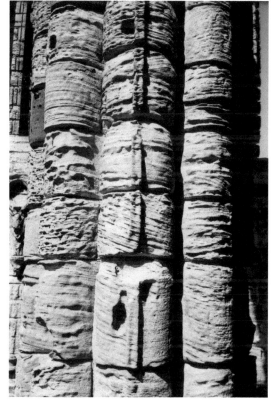

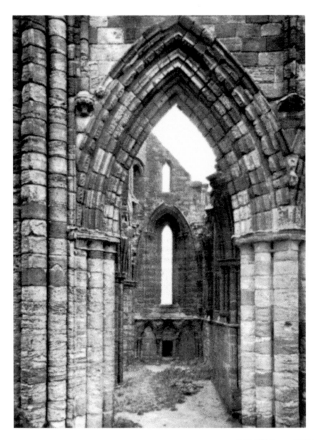

The Office of Prior

Next in dignity to the abbot was the prior, who also had his servants and his horses, and held the first place in the choir, chapter, and refectory. He presided in the monastery during a vacancy, and in the occasional absence of the abbot. Under him was the sub-prior, whose power was also considerable. He was charged with keeping a strict watch on the conduct of the monks in the dormitory, and the refectory, had custody of the keys of several offices and also officiated for the prior in his absence.

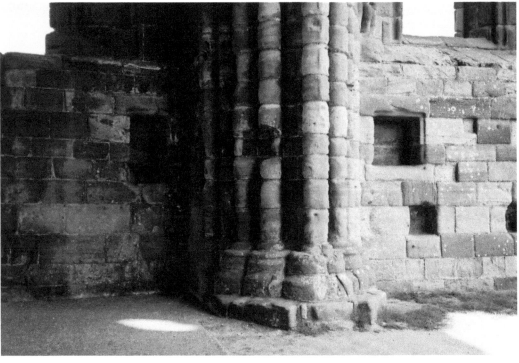

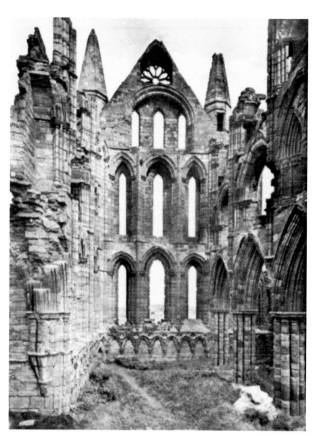

North Transept Interior
Above, captured in this photograph by Frank Meadow Sutcliffe, the north transept stands unkempt and at this date before 1920. It had not been excavated or cleaned of all the fallen and overgrown debris. Clearly an animal had created a well-trodden path, and today this can no longer be observed as the entire north transept has been lawned by English Heritage. The blind arcading on the wall below the three lancet windows and the rich foliated carved capitals are a diversion from the architectural decoration of the south transept.

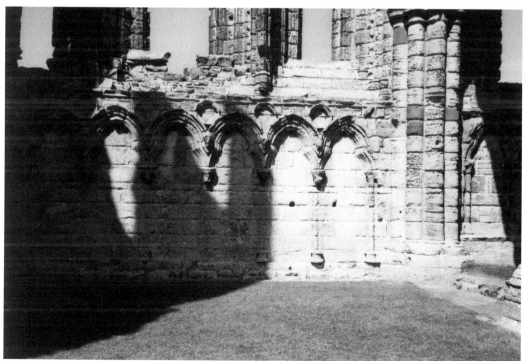

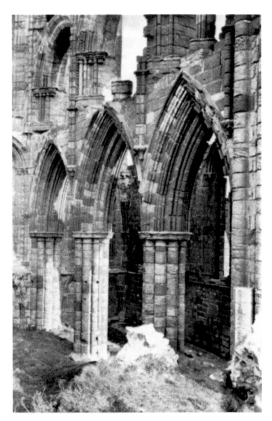

North Transept Arcade

A closer view of the north transept arcading, again a view by Sutcliffe, shows that at this date the overgrown debris has yet to be cleared. Once it was removed, at floor level it was possible to locate the original foundations of the earlier Romanesque church, which showed that the shorter transepts terminated in a curved wall known as an apse, and these foundations have been left uncovered. Below can be seen the footing of an altar, which was attended by a special monk (see page 76).

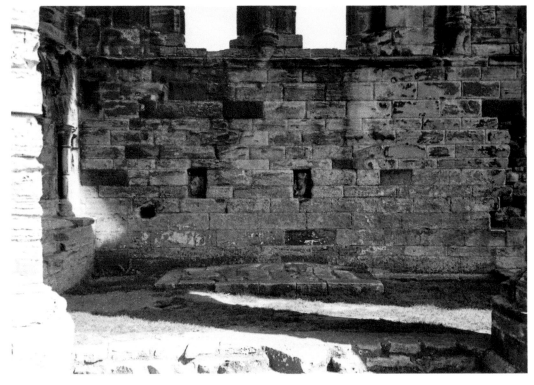

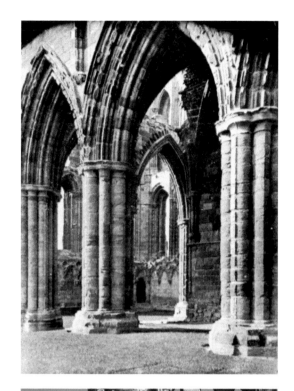

Abbots and Priors, Whitby Abbey

The Norman Abbey was founded by William de Percy who died on a crusade to the Holy Lands, *c.* 1097. Before he passed away he raised the status of Whitby Priory to that of an Abbey. As a priory, the head was known as the prior, the first to hold the most senior office were, in order:

Prior Reinfrid, *c.* 1029, then Prior Serlo who died *c.* 1102 and was in office for twenty years. William de Percy, nephew of the founder and of Prior Serlo was in office when the priory became an Abbey and became the first abbot 1109–*c.* 1129.
Nicholas *c.* 1128 – *d.* 1139
Benedict *c.* 1139 resigned
Richard de Burgh *c.* 1148 – *d.* 1175
Richard de Waterville *d.* 1178
Peter before 1190–1211
John de Evesham *c.* 1214 – *d.* 1222
Roger de Scarborough *d.* 1244
John de Stayngreve *d.* 1258
William de Briniston *d.* 1265
Robert de Langtoft *d.* 1278
William de Kirkham *d.* 1304
Thomas de Malton resigned 1322
Thomas Hawkesgarth resigned 1352*
William de Burton 1355–1374*
John de Richmond *d.* 1393*
Peter de Hertipole *d.* 1394*
Thomas de Bolton *d.* 1413
John de Skelton *d.* 1437
Dr Hugh Elerton *d.* 1462
Thomas Pickering *d.* 1475

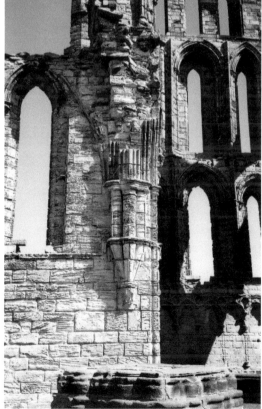

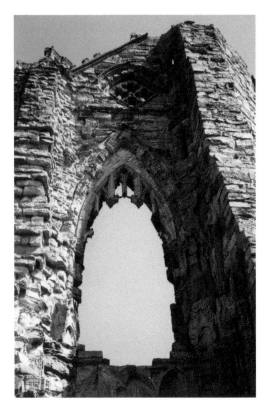

The Abbots Continued

William Colson *d.* 1499
John Lovel *d.* 1501*
William de Evesham *d.* 1505
John Benestede *d.* 1514
Thomas Bydnell *d.* 1516
John Whitby *d.* 1517
Thomas York *d.* 1527
John Topcliffe resigned 1538
Henry de Vall surrendered Whitby Abbey
to the King's Commissioner on 14
December 1540

*Abbots marked with * denotes that they were monks of Whitby Abbey who were elected into their position, rather than invited from other Abbeys and priories.*

The abbot, according to the regulations of the Benedictine Order, governed the monastery with almost unlimited power, and there was scarcely any appeal against his authority. Our abbot lived in great style. He had his hall, his chamber, his kitchen, and other offices apart from those of the convent. He had pages, valets, and other servants. On journeys he was attended by a retinue on horseback, and even his cook was allowed a horse; and chambers were provided for his reception in those parts of the territory that he had occasion to visit. He had also his own chaplain, or chaplains, who were changed every year, so that the witnesses of his good behaviour might be the more numerous.

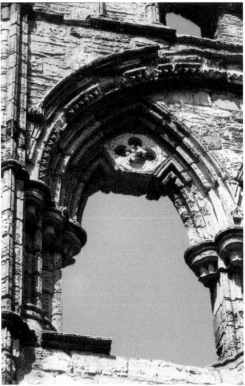

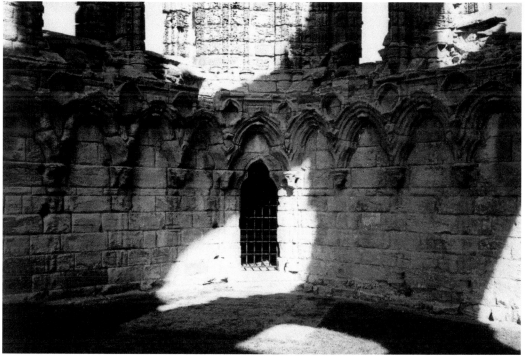

The Processional Way

Services would reflect the importance of High Days and Holy Days. The abbot and monks would dress in their finest, and great processions would take place both inside and outside the church; and not just on the ground floor. They would wind up within the walls to appear on the clerestory level and higher still, to the triforium. Entrance to these spiral stairs can be best seen in the corner of the north-west corner of the nave, below, and above, the entrances onto the clerestory and triforium can clearly be seen.

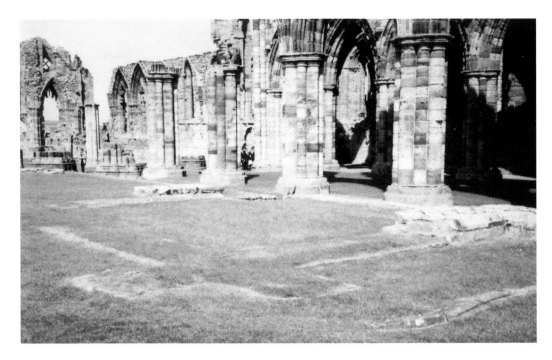

South Transept

The south transept, which largely collapsed in 1736, has its foundations marked in the grass. When the transept was rebuilt around 1240–50 it was extended south over a passage adjoining the shorter transept of the Norman church. Against its southern end stood the chapterhouse where the monks met daily to discuss the day's work or receive discipline, and above this was a large fourteenth- or fifteenth-century window as shown in an early engraving. Just outside the transept is the grave of an unknown monk, or possibly an abbot.

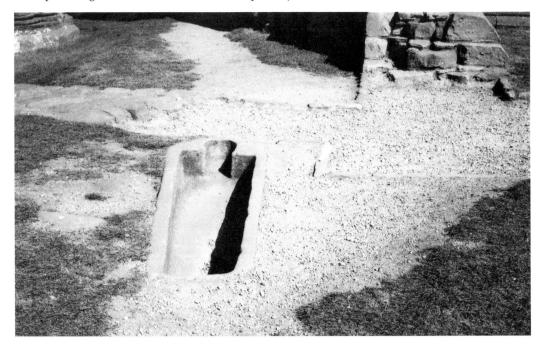

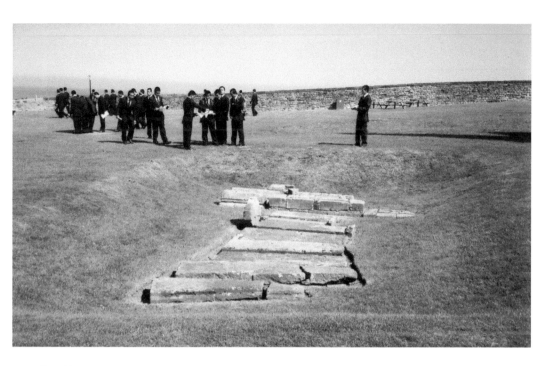

Lay Cemetery

The lay cemetery in the Middle Ages was to the north of the church. North of the nave, a group of tombs and tomb-slabs is exposed to view; one of these has head- and foot-stones cut with wheel-crosses. The day I visited the Abbey to take these photographs in June 2011 a company of Ghurkha soldiers were on a visit also, and are seen here admiring and discussing the group of tombstones. Little did they know that by September of this year they were likely to be disbanded under proposed sweeping defence cuts.

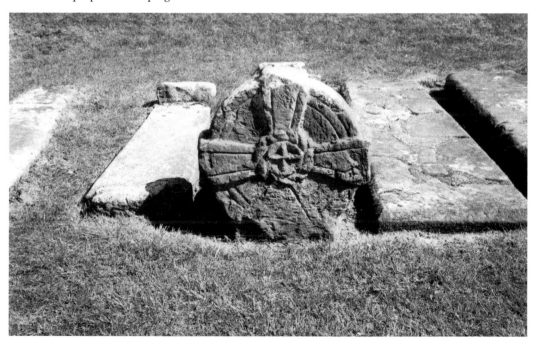

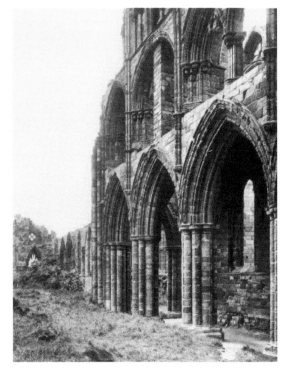

The Monks of Whitby Abbey

The Revd Young (1817) states that at the election of an abbot in 1393, the chapter consisted of the following monks:

John Allerton, Prior
Thomas de Hawkesgarth, Prior of Midelsburgh
Peter de Hertilpole, Bursar (later Abbot)
Reginald de Esyngtun, Sacrist
Robert de Boynton, Subsacrist
William de Ormesby, Almoner
Stephen de Ormesby, Infirmarer
William de Yarme
William de Bokyngham, Master Builder
Robert de Middillesburg, Kitchen Cellarer
Thomas de Hakeness, Chamberlain
William de Dalton, Cellarer
Thomas de Dolton, Cellarer
Thomas de Bolton (later Abbot)
Thomas de Elyngton, Precentor
Roger de Pykryng, Master of the Blessed Virgin's Altar
John de Ryston, Hostler
Thomas de Butterwik, Subchantor
John de Whitteby
William de Garton, monk
Hugh de Garton, monk

Elsewhere he also names the following as monks at the same date:

Adam, Alexander, Aschetine, Bartholomew, Constantine, Everard, Geoffrey, Geoffrey (2), Gregory, Henry, Hervey, Hugh (2), John (2), Martin, Maurice, Michael, Nicholas, Odo, Peter, Ralph, Ralph (2), Ralph (3), Ralph (4), Rannulf, Richard, Richard (2), Walter, Walter (2)

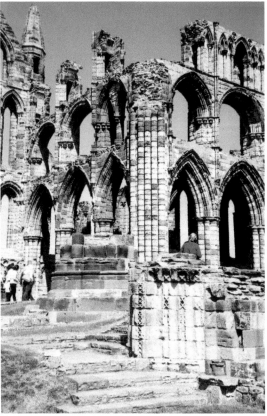

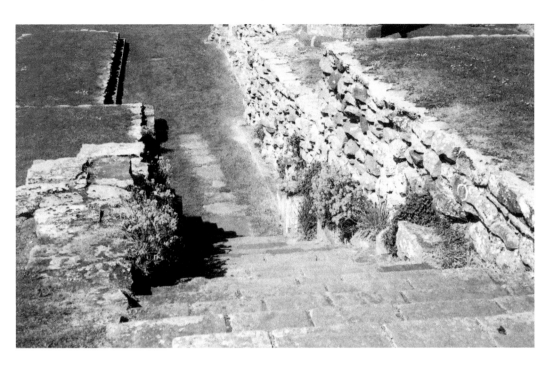

South Transept Passage

During the twelfth century, a passage that connected the two levels of the church ran alongside the outer wall of the south transept, seen above looking down the short flight of steps onto the lower level. The purpose of this passage is not clearly understood. However, through centuries, the exposed weathered stone of the Abbey ruins has become home to a number of hardy species of plants that have rooted in the stonework, bringing to mind the title of a popular early twentieth century song, 'In a Monastery Garden'.

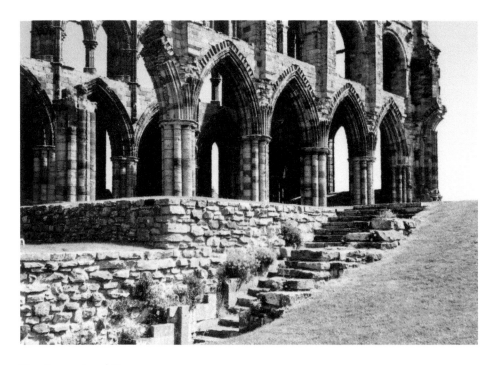

The Processional Doorway

The eastern side of the eastern processional doorway from the cloister to the church is still standing, a work of around 1240 with shaft-bases, foliage-capitals and 'dog-tooth' ornament. Against the end of the south transept stood the chapterhouse, part of which is shown standing in Buck's view of 1711. It is recorded to have been rebuilt by Abbot Richard of Peterborough. The refectory no doubt occupied the south side of the cloister and the cellarers range the west side, but of these nothing remains except part of the passageway or outer parlour.

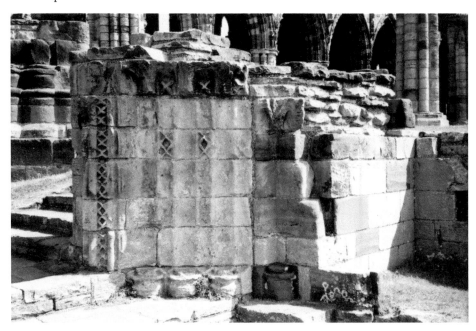

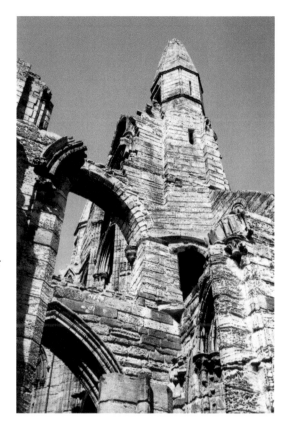

The Cellarer

Next in rank may be placed the cellarer or rather the cellarers, for there were two officers of that name belonging to our Abbey, and to other large monasteries. The one was simply called the cellarer or sometimes the general or outward cellarer (*cellerarius generalis vel exterior*) by way of distinction. He was the grand steward of the convent, who superintended their estates and managed possessions and the transactions relating to them. He conducted sales, leases, and purchases of property, and did homage for the lands that were not exempted from secular service. He had his riding horses, and a page to wait on him, and there was a sub-cellarer to assist him. The other officer of that name was the kitchen cellarer (*cellerarius coquinae*), or steward of the kitchen. It was his province to provide all the supplies for the kitchen and the refectory, to take charge of all the stores, and give them out as occasion required. He was the master of the household who supplied the whole convent with food, fuel, vessels, and all things necessary for their entertainment. Of course he had to be an adept in the system of fasts and feasts, and know what kind of meat or drink each day was to be kept holy.

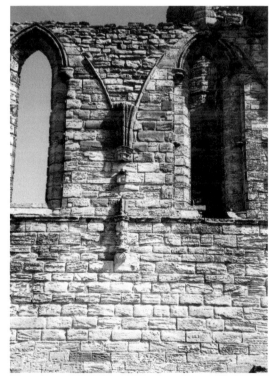

Pageant of Whitby, 1964

In 1964, the town of Whitby held a historical pageant to commemorate the 1,300th anniversary of the Synod of Whitby, which took place in AD 664. The pageant occurred in the Abbey grounds in June 1964 and was compiled by the Revd Donald R. Dugard. The producer of the spectacle was Sister Mary Nina of the Order of the Holy Paraclete – an order who have a presence in the town. Various scenes were enacted portraying events in the life of the Abbey. Above we see St Hilda as portrayed in the Pageant of Whitby.

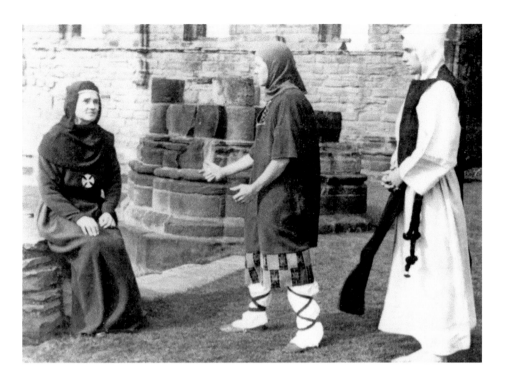

Pageant of Whitby, 1964

Two scenes from the pageant: the upper showing the illiterate cowman Caedmon reciting his dream to St Hilda, while below, the story of how an assassination attempt on the life of King Edwin was thwarted by his devoted Christian manservant Lilla, who sprang between the assassin and king and took the deathblow. He died as a result of his action, and to honour the valour of Lilla, a stone cross was erected on the moor where he fell, now called Lilla Cross. King Edwin became a Christian and founded York Minster.

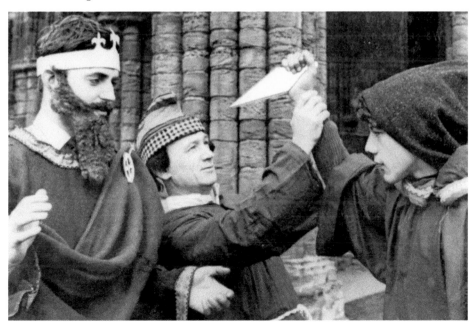

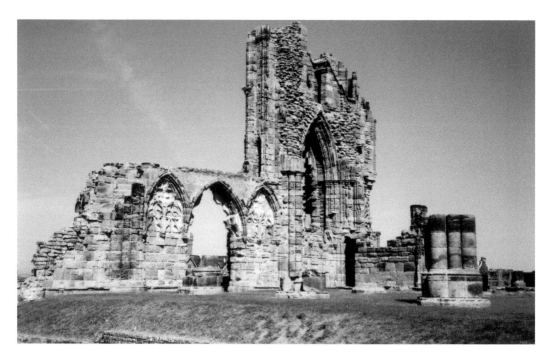

The Precentor

The precentor or chantor was another officer of high rank. He conducted the service of the choir, and the charge of the missals, breviaries, and other service books, and distributed the robes at festivals. The choristers and organists were under his direction and he had the custody of the Abbey seal and the chapter book, in which were written all the minutes of the daily and special meetings. The concerns of the library were also entrusted to his care. He was assisted by the sub-chantor.

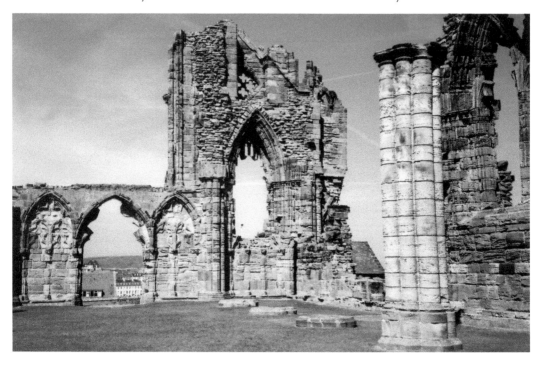

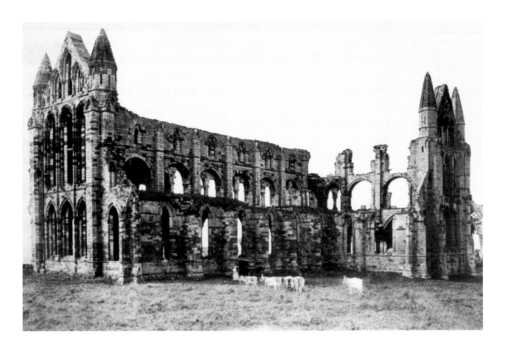

The Sacrist

The sacrist, or secretary, who was aided by a sub-sacrist of equal dignity who would officiate if the sacrist was absent, had charge of the ornaments of the church, and furniture of the altar; the chalices, the vestments, candles, the communion bread and wine, along with other objects relating to the service of the church. He also had charge of the bells and the cemetery, and supervised the burial of the dead.

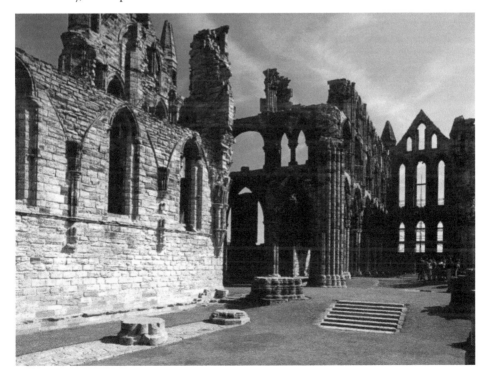

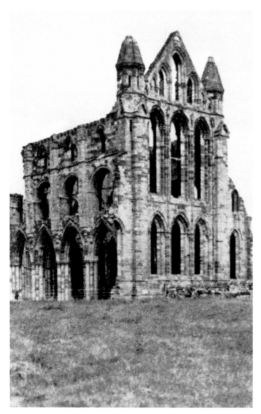

The Bursar

The bursar, or treasurer, had an important trust, as he received and disbursed the public money of the monastery and kept all the accounts. He was allowed a horse, which the duties of his office rendered highly necessary as we find from the Rolls that he had numerous journeys to perform for receiving and paying money, and frequently attended synods, convocations, and other public occasions. For a long number of years the Abbey had its own tollhouse in the market place at the end of Grape Lane, still referred to by locals as the 'tatie market' where tenants would pay their rents. The Chamberlain (*camerarius*) took care of the dormitory and its appurtenances, provided the wearing apparel of the brethren, furnished caps, spurs, and other travelling apparatus for such as were going on a journey, and also attended to the shoeing of the riding horses.

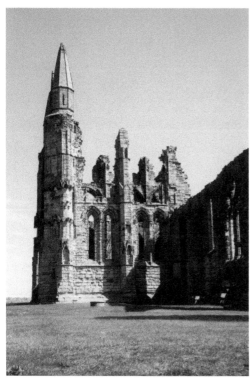

Other Officers of the Abbey

The refectioner, as his name imports, managed the concerns of the refectory, having under his charge the tables, table-linen, dishes, plate, and other articles belonging to that office; which he set in order at the beginning and removed at the end of each entertainment. He had servants to assist him in these duties. The hostler or hospitaller, was employed in attending to the guesthouse, and providing for the entertainment of strangers. The infirmarer was governor of the infirmary, and waited on the sick, for whose comfort he was allowed a kitchen and cook apart from those of the convent. Some medical skill would be an almost indispensable qualification for this office. The almoner disbursed the charities of the house; and he not only distributed to the poor at the gates of the monastery but was directed to seek out the abodes of the sick and the needy, that he might visit and relieve them. In such excursions, however, he was forbidden to associate with women, lest those visits of mercy should be employed to cover intrigues of love.

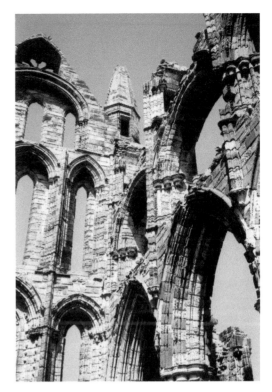

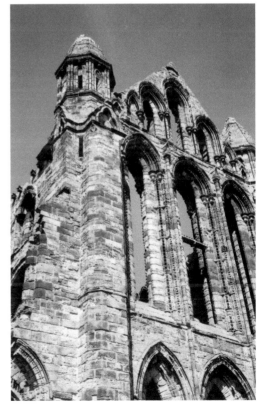

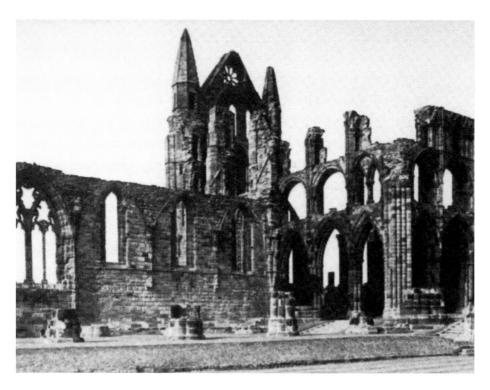

The Master of the Altar

All these officers, except the sub-cellarer and refectioner, are mentioned in the Whitby records, and all of them were chosen from among the monks either by the appointment of the abbot, or rattler by the election of the whole chapter. There was also at Whitby another officer, a member of the chapter, entitled the Master of the Blessed Virgin's Altar. He conducted the service of the Virgin Mary, which must have been carried on in the north transept of the Abbey church.

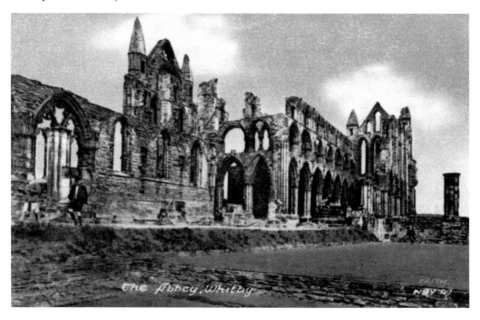

The Abbey, Whitby

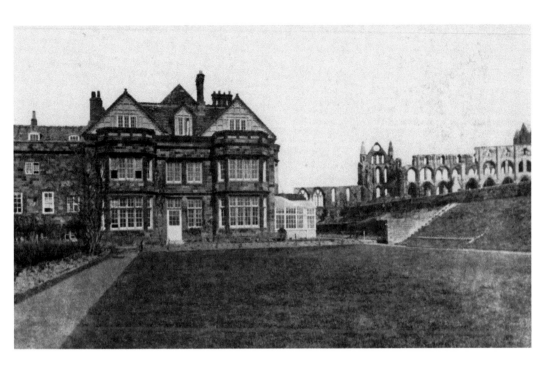

Abbey House

To the south-west of the Abbey stands a major group of buildings. This was formerly a residence of the Cholmley family, who acquired the Abbey and its estates in 1540, and owned it until the twentieth century. The buildings are in two parts to either side of a courtyard. At the back is a much altered medieval building with a substantial Victorian wing. In the early seventeenth century, Sir Hugh Cholmley I (1600–57) remodelled the medieval buildings here, probably forming a compact courtyard residence approached from the north, which was further altered.

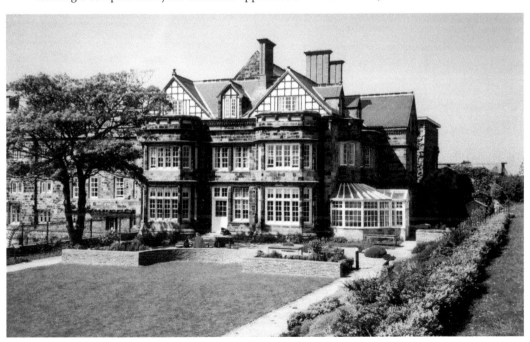

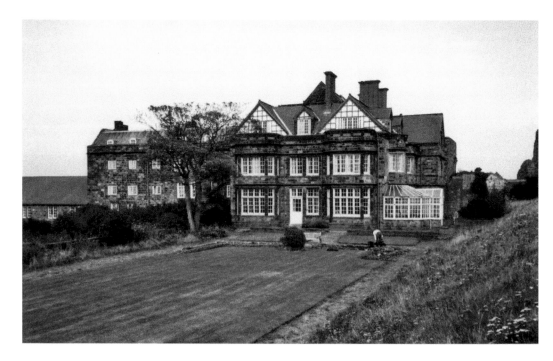

Abbey House

In 1866 the house was again extended by Sir Charles Strickland, who added the Victorian wing and conservatory to make it into a summer residence. Thirty years later, in 1896, Abbey House was leased by the Cholmley estate to the Countrywide Holiday Association as a holiday hotel and continued as such until the 1990s. Today the YHA run it as a luxury hostel for its members, and it is occasionally open to the public. The house has numerous interesting features, including medieval fireplaces, a seventeenth-century staircase and a room with Georgian panelling.

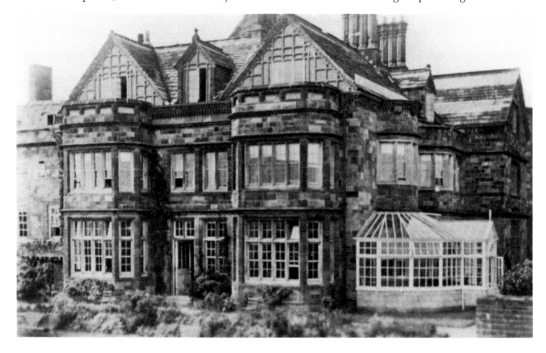

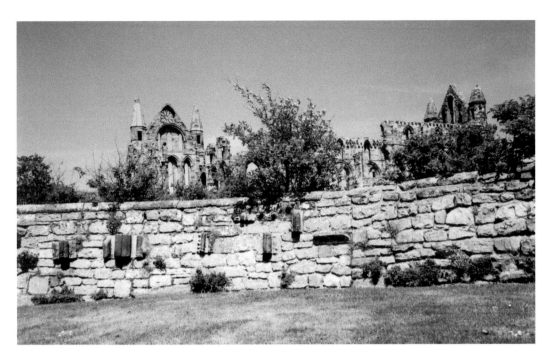

Abbey House Boundary Wall

In 1920 the Abbey ruins were taken into the guardianship of the Ministry of Works, later to be renamed English Heritage. It was probably at this date that Abbey House was walled off from the ruins as people were admitted to the Abbey on a regular basis. The wall was built of stone lying about the property and, because of that, it incorporates a large number of sculptured pieces from the Abbey itself – few of importance, just carved pieces of fallen and discarded masonry.

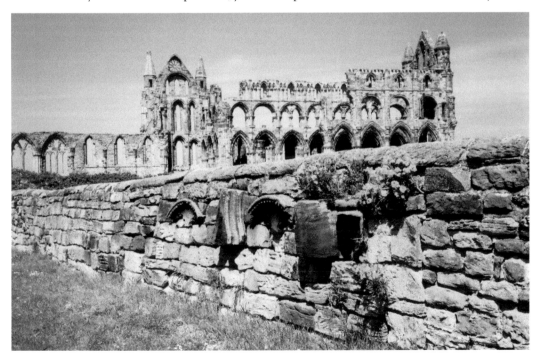

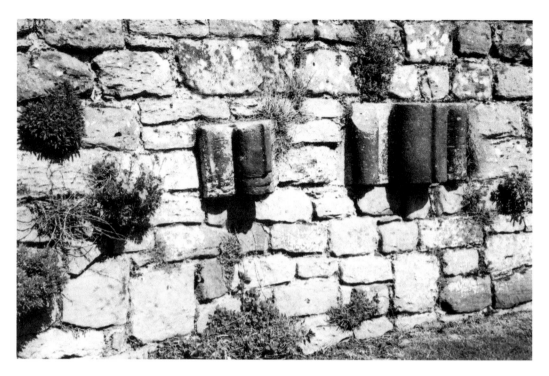

Abbey House Boundary Wall

By 1993 the boundary wall had fallen into disrepair, and the grounds of Abbey House had become overgrown, so it was decided to restore both the garden and rebuild the wall. A package of advice and money was put together with English Heritage and the CHA garden fund, and other bodies. My job was to oversee the actual building work onsite, which was undertaken by volunteers of the British Trust for Conservation Volunteers (BTCV) and labourers funded by the North Yorkshire Training and Enterprise Council under the title of Whitby Environmental Improvement Project.

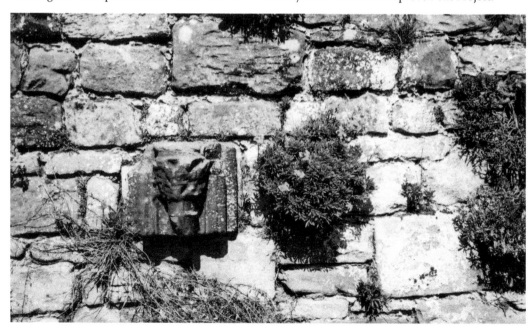

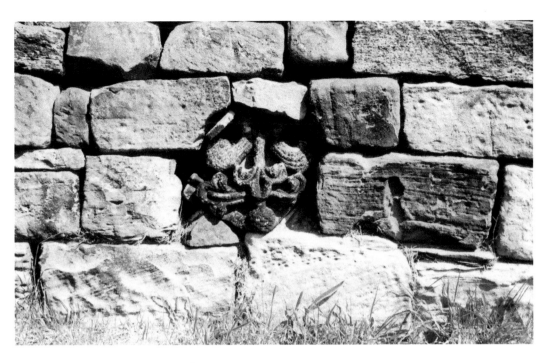

Abbey House Boundary Wall

While a majority of the stones incorporated into the boundary wall were of no importance, as they were in the main sections of columns and vaulting, one or two more elaborate stones did make it into the stonework, such as the stone-carved boss, above, which would have formed the centrepiece to a ceiling. Below, this stone once formed part of an elaborate window manufactured in sections; the stone being inserted out of context, forming a circular with four terminations in the manner of a *fleur-de-lis* as seen on page 62.

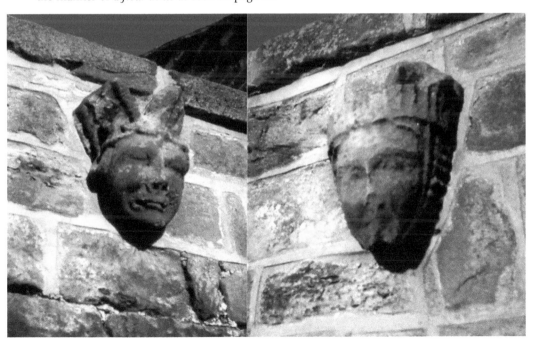

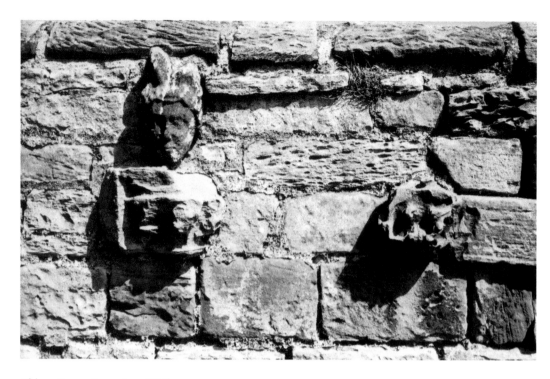

Abbey House Boundary Wall

Among the sculptured stones were figures in the form of human heads, both male and female, in the costume of the period spanning the fourteenth to sixteenth centuries. It is not known where these came from, but certainly they would have formed some aspect of the Abbey's decoration. It is probable that these figures were the heads of donors who had given money or lands to the Abbey, who in return would pray for their souls in chapels set up in the transepts of the Abbey church.

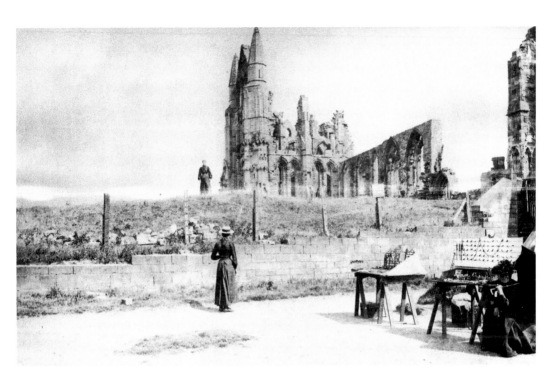

Jet Sellers Outside Whitby Abbey

This photograph, taken around 1900, shows one of three ladies who ran this stall, named Ms Walker, Middlemass and Jackson. They occupied this site for many years during the summer months, carrying their wares up the 199 steps in a tin trunk, which was stored under the table. The monks carried on a lucrative trade during the medieval period selling jet crucifixes to visiting pilgrims and numerous examples have been found. Today the site is occupied by Messrs Trillo's ice-cream van, a long-established family firm in Whitby.

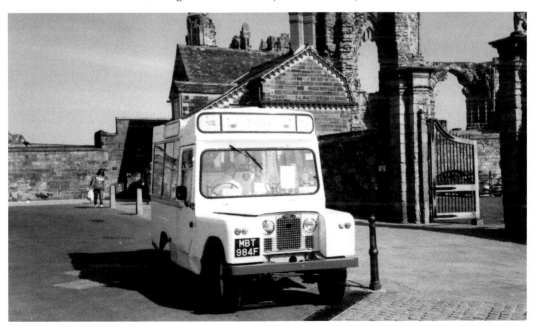

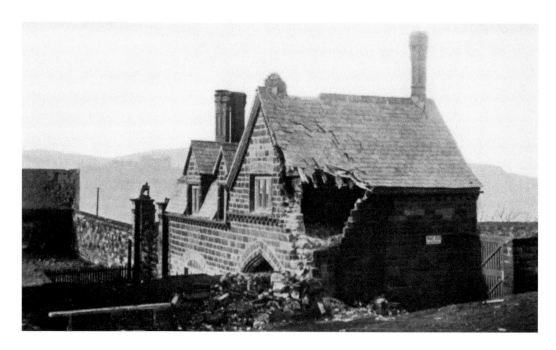

Abbey House Gatehouse

The photograph above shows the damage inflicted by two German battleships on 18 December 1914, when they sailed up the East Coast and fired on the defenceless town, having already attacked Scarborough and before moving on to shell Hartlepool. Below is an interesting postcard published by the Rotary Photographic Co. showing the Abbey under fire, a stock photograph with additional shell bursts and part of the Abbey ruins deliberately ruined to show the actual damage. I had another one showing an old lady having a picnic in the Abbey grounds as shells burst around her!

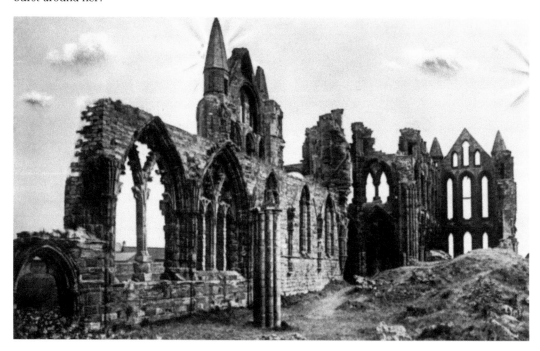

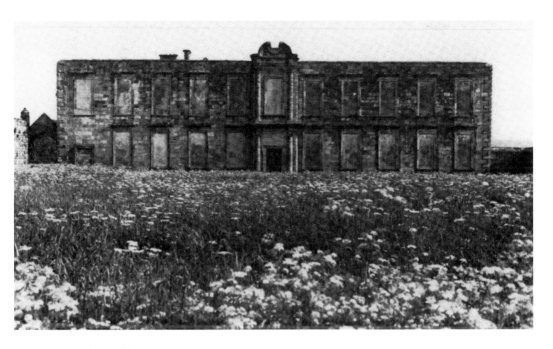

North Wing, Abbey House

Sir Hugh Cholmley (1632–89) created an impressive pair of entrance courtyards to the north of his new wing, completed by March 1674, which he may have designed himself. This wing lost its roof in a gale in 1790, from which time it lay abandoned. In recent years investigations located a fine stone pedestal, set into the retaining wall, which overlooks the courtyard, and was recognised as having likely been the original plinth to a statue in the courtyard. It is not known what happened to the statue, which disappeared in the eighteenth century.

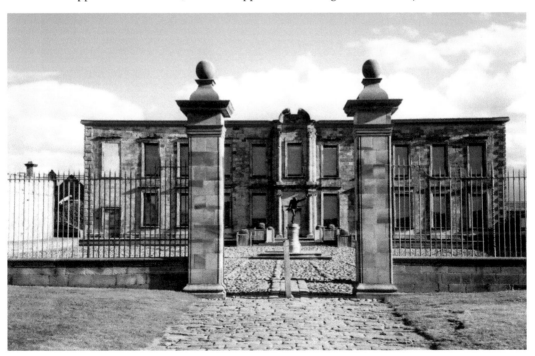

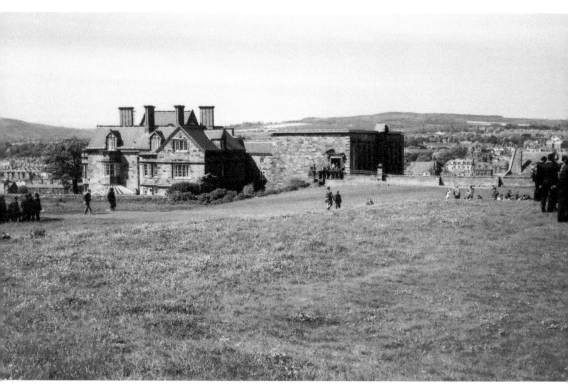

The Visitor Centre

In 2001 a new visitor centre was created in the shell of the north wing to the design of architect Stanton Williams, to house a shop and exhibition. It was opened the following year on Easter Sunday by the Archbishop of York. Window apertures were carefully opened up and a glass 'greenhouse' was erected inside the Grade I listed walls so as not to cause any damage. Below, a self portrait of a photographer at work reflected in the glass door that gives entrance into the new visitor centre on the upper level.

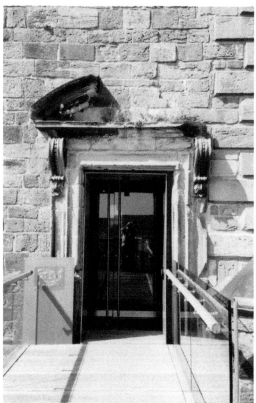

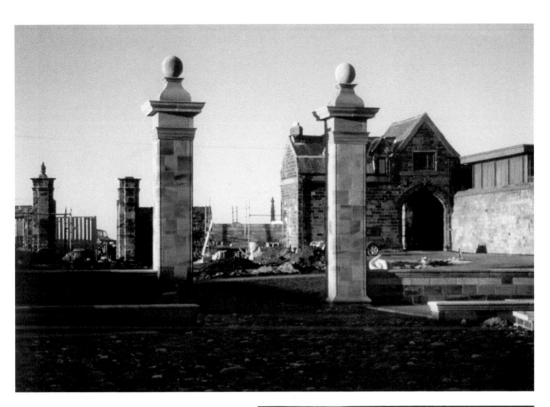

The Inner Courtyard

The inner courtyard had long been covered in grass, but archaeological excavations in 1998/99 revealed that the inner court had a rough layer of cobbles, with an irregular pattern formed by lines of larger stones. This is something of a puzzle, as this surface could not possibly have been crossed by horses or carriages. It may be that the cobbles were meant to show as a pattern through a surface of something like gravel or lime concrete. In the middle of the cobbles the excavation revealed the foundations of a broad, stepped platform.

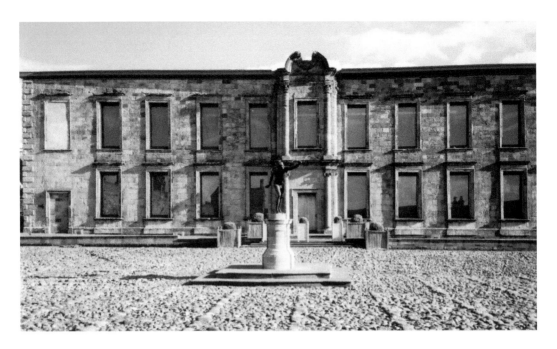

The Whitby Gladiator

In 1682 the Yorkshire historian, Ralph Thoresby, referred to as a 'curious figure in solid brass as large as life in the midst of the square' at Sir Hugh's house. Research has identified this as a copy of the Borghese Gladiator, which was known in England from a copy made for King Charles I by the French sculptor Hubert le Sueur, now at Windsor Castle. As an officer of the royal household, Hugh Cholmley II would have known it well and his gladiator may have been cast from this version. It was unveiled in 2009.

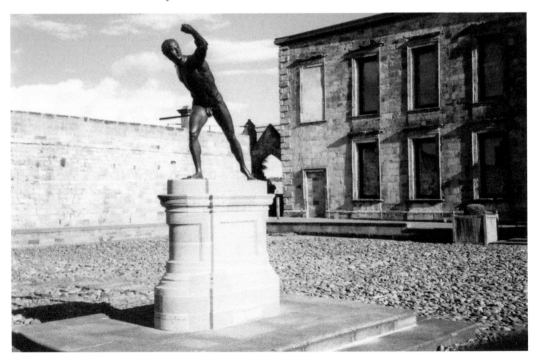

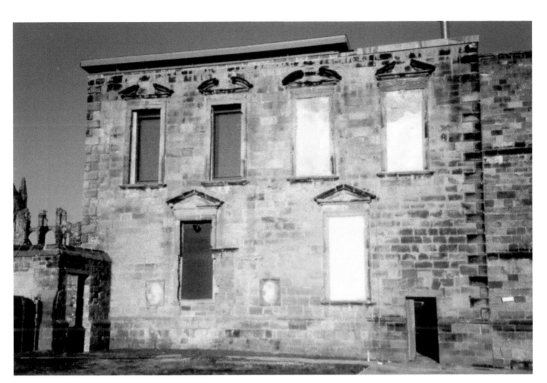

The North Wing, West Façade

Around the corner of the north wing the façade changes in character, with offset windows and prominent pediments above them. This suggests that it might have been designed by Sir Hugh himself, who, as an amateur, was more preoccupied with including fashionable architectural features than in achieving a consistent design. However, there is a single reference to a mason called Longstaffe or Langstaffe, probably the John Longstaffe (1649–1719) who settled in Whitby. Below, a blocked door, which was opened up to provide access to the visitor centre from the Abbey grounds (see page 89).

The Visitor Centre Exhibits
Within the north wing of Abbey House, English Heritage set up an exhibition space to display many of the artefacts uncovered in excavations. Above is an example of an early grave marker dating from the ninth century. Below, a seventh/eighth-century baluster shaft – a central support for a window opening – which is the one surviving piece of stone that may have come from the first stone church on the headland. It is thought that this is contemporary with the monastery at Monkwearmouth where similar if not identical pieces have been found.

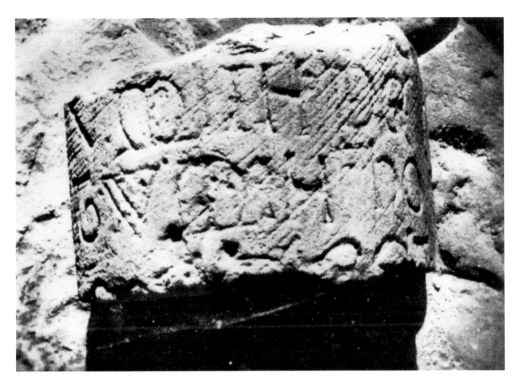

Detail of Inscribed Stone
On the north pillar in the north transept, facing the north-east angle, there has been an inscription on a column in the cluster. This inscription probably relates to the erection of the transept, but in 1817 it was said to be in a very mutilated state. The middle part of the inscription was entirely gone due to a labourer thinking it spoke of gold and hacking it out, but it was discovered. Below, a grotesque corbel in the form of a head, probably of fourteenth-century date, on show in the visitor centre.

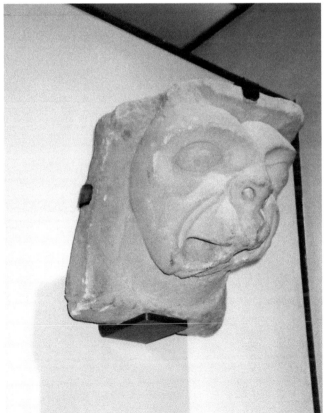

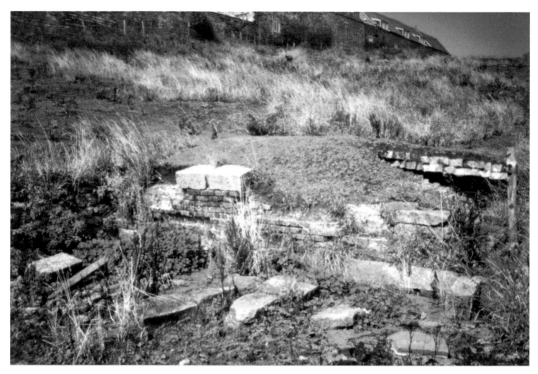

The Courtyard Buildings

Sir Hugh Cholmley (1600–57), in the last two years of his life after the death of his wife, wrote his memoirs for the benefit of his sons, from which this passage is extracted: 'I removed the spring following into the Gate-house at Whitby, where I remained till my house was repaired and habitable, which then was very ruinous and all unhandsome, the wall being only of timber and plaster, and ill contrived within: and besides the repairs, or rather re-edifying the house, I built the stable and barn, I heightened the out-walls of the court double to what they were, and made all the wall round about the paddock; so that the place hath been improved very much, both for beauty and profit, by me more than all my ancestors, for there was not a tree about the house but was set in my time, and almost by my own hand. The court levels, which laid upon a hanging ground, unhandsomely, very ill-watered, having only the low well, which is in the Almsers-close (top), which I covered; and also discovered, and erected, the other adjoining conduit, and the wall in the court-yard, from whence I conveyed by leaden pipes water into the house, brew-house (bottom, doorway to brewhouse) and wash-house'.

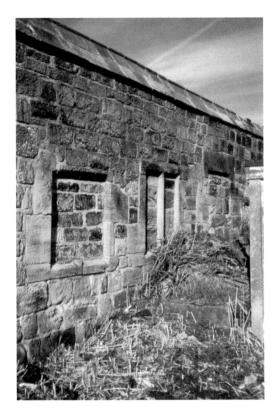

The Memoirs of Hugh Cholmley

'In December 1635, upon a Tuesday, was born my daughter Ann, at the said Gate-house; and baptized in the church of Whitby, by Mr. Remmington... In Spring, 1636, I removed from the Gate-house into my house at Whitby, being now finished, and fit to receive me; and my dear wife... I did not only appear at all public meetings in a very gentlemenly equipage, but lived in as handsome and plentiful fashion at home as any gentleman in all the County, of my rank. I had between thirty and forty in my ordinary family, a chaplain who said prayers every morning at six, and again before dinner and supper, a porter who merely attended the gates, which were ever shut up before dinner, when the bell rung to prayers, and not opened till one o'clock... Twice a week, a certain number of old people, widows and indigent persons, were served at my gates with bread and good pottage made of beef, which I mention that those which succeed may follow the example.' Above, an architectural detail on the range of surviving outbuildings, blocked-up Tudor window and doorway. Below, a surviving seventeenth-century fireplace at the rear of the north wing.

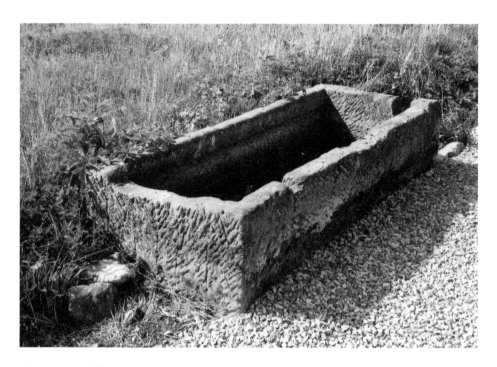

The Outer Buildings

Above is one of the huge stone water troughs from the monastery. Rainwater was collected in these and placed around the complex for watering the animals and plants. Drinking water came from springs. Below, the nineteenth-century Abbey gatehouse as it stands today, now a ticket office. When I was tour guide on the open-top bus some years ago, we parked up on the Abbey headland for a break to allow passengers to walk around, and at that date this was a private residence with a small garden in front.

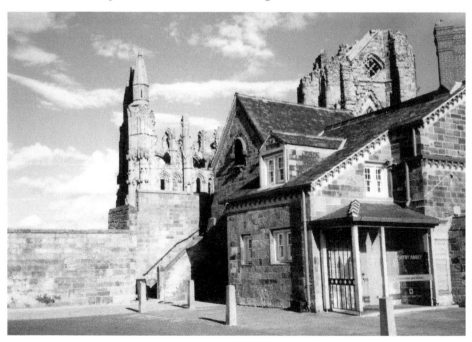

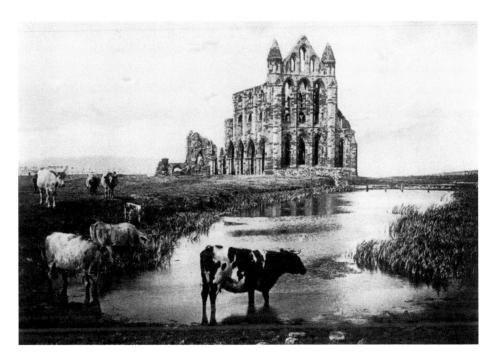

Whitby Abbey at Sunset

Atmospheric views of the Abbey at sunset, when the bats take to the air. Images such as this possibly inspired Bram Stoker. There is also a tale of a ghost who haunts the Abbey ruins, a white lady or nun, who was walled up alive as punishment for some misdemeanour. The poet Wordsworth laid out the story in his epic work *Marmion*. And there is the legend of how St Hilda turned all the snakes on the headland into stone and cast them down on to the beach, where today coiled fossil ammonites can be found.

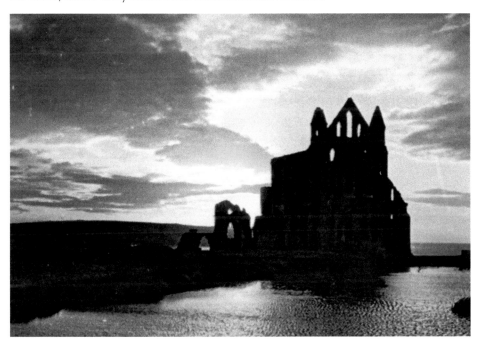

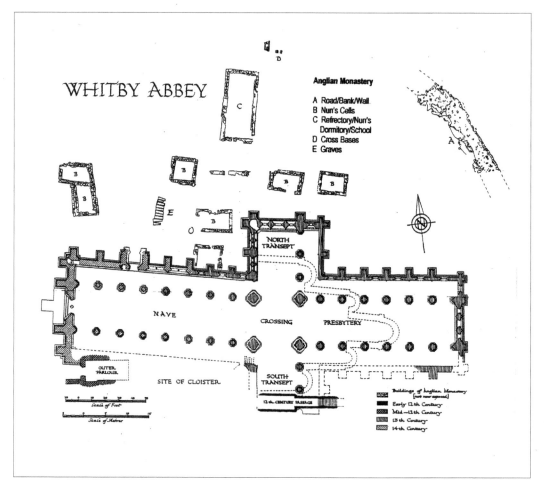

Ground Plan of Whitby Abbey

Acknowledgements

Much of the textural material is adapted from the book *Whitby History Vol.1* by the Revd George Young (1817) and the latest edition of the official *Guide to Whitby Abbey* (2010) by English Heritage. The photograph on page 6 is copyright to the National Monuments Record, Page 18 National Portrait Gallery, London, Page 19 Private Collection, Charles Plante Fine Arts.